ideals® CHRISTMAS

The earth has grown old with its burden of care,
but at Christmas it always is young;
the heart of the jewel burns lustrous and fair,
and its soul full of music breaks forth on the air,
when the song of the angels is sung.

—PHILLIPS BROOKS

NASHVILLE, TENNESSEE

Home for Christmas
Mamie Ozburn Odum

There's a joyous, happy feeling
with the tree gleaming so bright,
our house is gay in wreaths
 and holly
as the snow falls soft and white.
And there's merry song and laughter
as the loved ones come, one by one,
with mysterious wrapped packages—
some for merit, some for fun.
There's roast turkey in the oven
and fine cakes that all adore;
there are pies, pickles, and candy
with nuts and apples by the score.

Home for Christmas, how we love it,
the sweetest time of all the year.
All a-shouting, "Merry Christmas"
to homefolks we love most dear.
All the children gather closely
waiting for old Santa's flight
with the church bells merrily
 ringing,
honoring His birth this holy night.

Our Hearts
Marion Schoeberlein

Our hearts remember
 Christmas
no matter where we roam.
Somehow at Christmastime,
 we all,
within our minds, go home
to share the gay festivity,
to know the meaning of
a day filled with such happiness,
such brightness, and such love!

Our hearts remember
 Christmas
wherever we might be.
Somehow at Christmastime
 we all
exclaim the poetry
in skies, with angels as they sing
the beautiful refrain
of so long ago,
"Peace on earth, goodwill
 to men."

Christmas Blessings
Gladys Shuman

Christmas means holly and tinsel,
the glow of candlelight too,
sharing the warmth of a fireside
and gifts, with good friends like you.

Christmas means happy laughter,
good cheer, over all of the earth,
but the deepest joy of Christmas
is our dear Savior's birth.

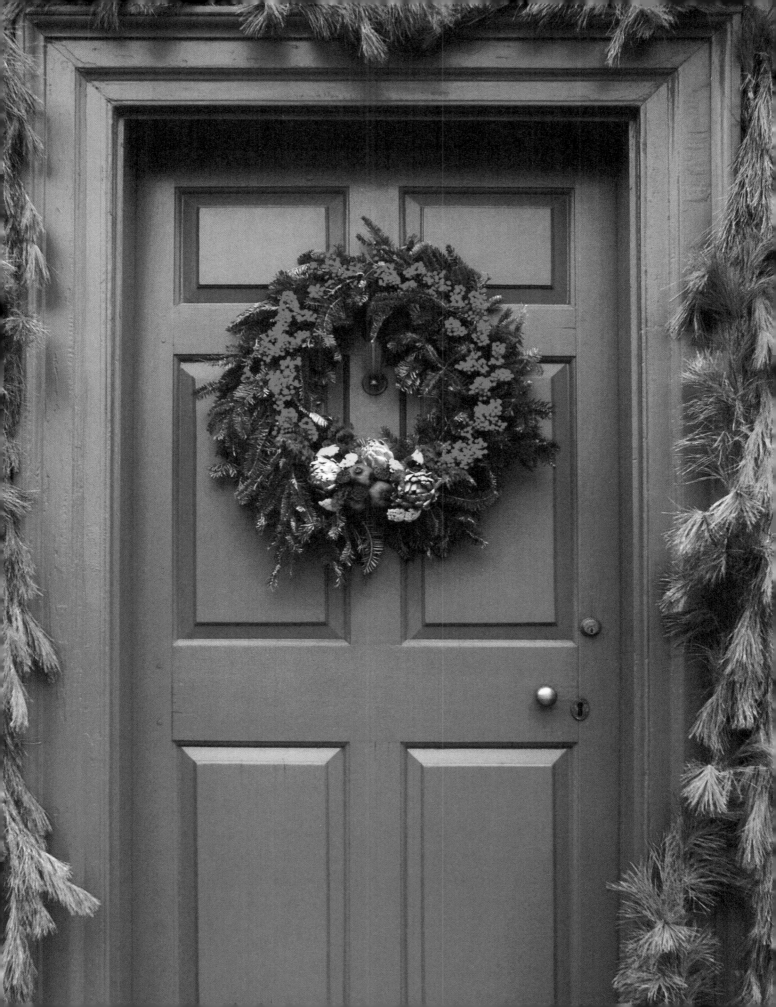

When Pecans Started Falling

Lillian Smith

Christmas began when pecans started falling. The early November rains loosened the nuts from their outer shells and sent them plopping on the roof of the veranda. In the night, you'd listen and know it would soon be here.

It was *not* Thanksgiving. We eased over the national holiday without one tummy ache. Turkey? That was Christmas. Pumpkin pie? Not for us. Sweet potato pie was Deep South dessert in the fall. We had it once or twice a week. Now and then, Mother varied it with sweet potato pone—rather nice if you don't try it often. Raw sweet potato was grated and mixed with cane syrup, milk, eggs, and spices and slowly baked, then served with thick, unbeaten cream: plain, earthy, caloric, and good. But not Christmasy.

Pecans were. Everybody in town had at least one tree. Some had a dozen. No matter. Pecans were prestige. They fit Christmas.

And so you lay there, listening to the drip-drip of rain and plop-plop of nuts, feeling that something good is going to happen, something good and it won't be long now. And you'd better sneak out early in the morning before your five brothers and three sisters and get you a few pecans and hide them. Strange how those nuts made squirrels out of us. Nothing was more plentiful, yet we hid piles of them all over the place. Of course, when there are nine of you and the cousins, you get into the habit of hiding things.

But on tree-shaking day we were meek. We said proper verses, we bowed our heads for the blessing, we ate quickly, did not kick each other, or yap at Big Grandma.

The moment we were excused from the table, we ran to the linen closet for old sheets and spread them under the trees as our father directed. We got the baskets without being told. We were gloriously good.

Whoever won, by fair or foul means, the title of "shaker of the tree" did a pull-up to the first limb, hefted himself to the next, skittered onto the branches, and began to shake. Thousands of nuts fell until sheets were covered and thickening. Everybody was picking up and filling the baskets, except the little ones who ran round and round, holding their hands up to catch the raining nuts, yelping when hit, dashing to safety, rolling over the big boys' bird dogs, racing back.

This was how Christmas began for us. Soon the nuts had been stored in old pillowcases. Our neighbors used croker sacks; I don't know why we preferred old pillowcases. After a few days of what our mother called "seasonings," the picking out of the nutmeats took place.

Christmas Eve came. All day, Mother and Grandma and the cook and the two oldest sisters

worked in the kitchen. Fruitcakes had been made for a month, wrapped in clean white towels, and stored in the dark pantry. But the lean pork had to be ground for pork salad, the twenty-eight-pound turkey had to have its head chopped off, and then it must be picked and cleaned and hung high in the passageway between house and dining room; then coconuts had to be grated for ambrosia and for the six-layer coconut cake and eight coconut custard pies, and you helped punch out the eyes of the coconuts. Then, of course, you needed to drink some of the coconut milk; and as you watched the grownups grate the nutmeats into vast snowy mounds, you nibbled at the pieces too small to be grated—and by that time you felt sort of dizzy, but here came the dray from the depot, bringing the barrel of oysters in the shell (they were shipped from Apalachicola), and you watched them cover the barrel with ice, for you can't count on north Florida's winter staying winter. It was time then to lick the pan where the filling for the Lord Baltimore cake had been beaten and somebody laid down the caramel pan—but you

tried to lick it and couldn't; you felt too glazy-eyed and poked out. And finally, you lay down on the back porch in the warm sun and fell asleep.

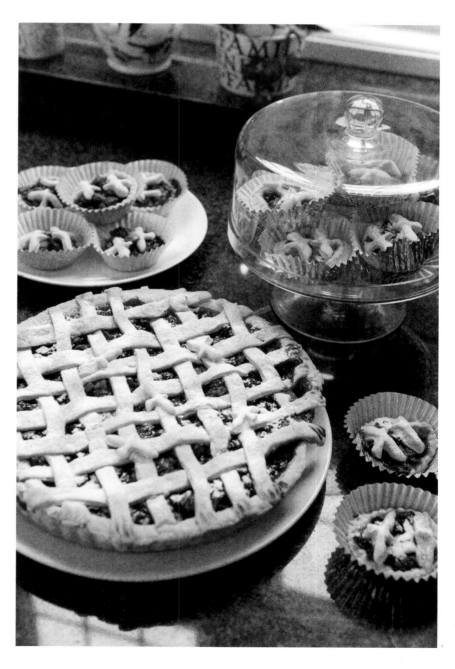

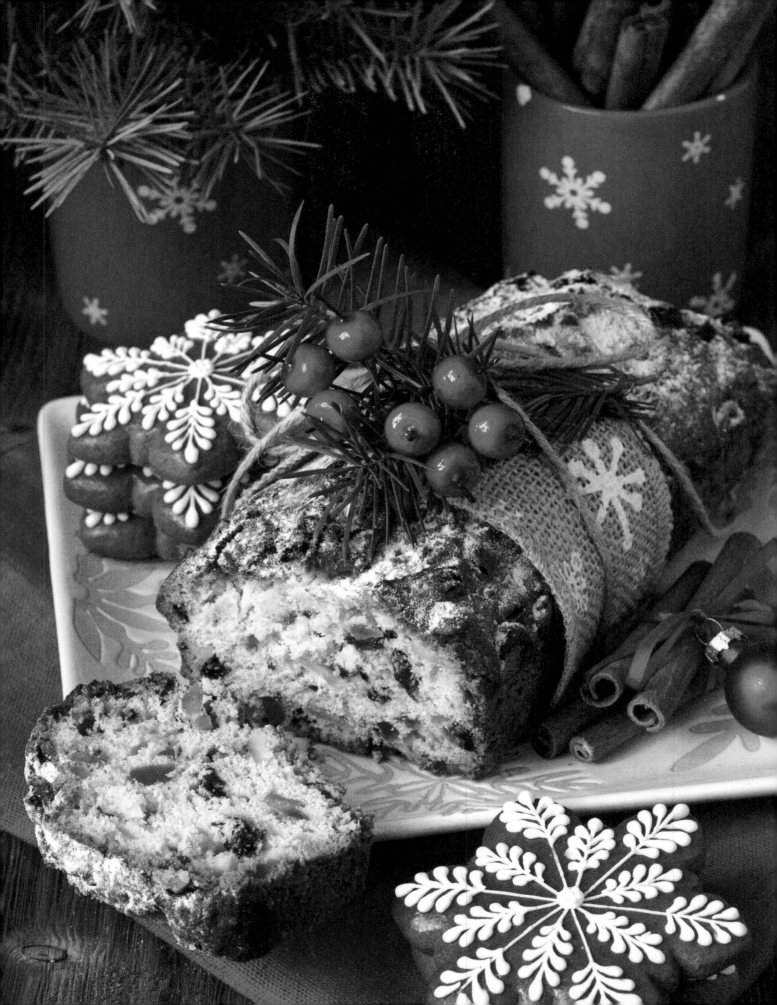

Christmas Fragrance
Solveig Paulson Russell

It's Christmastime at our house,
anyone could tell;
even if you couldn't see,
you'd know it by the smell.

There's fragrant air a-drifting;
it's loaded with good sniffs
of gingerbread and popcorn
and baking cookie whiffs.

The kitchen's full of odors
of pudding, steam, and cake,
and lots of other goodies
Mother likes to make.

There's aroma from the greens, too,
that mingles with the rest;
but if the truth be really told,
I like food fragrance best.

For I think the Christmas bouquet
is a treat that's hard to beat
with its tantalizing promise
of the things we're going to eat.

The Fragrance of Christmas
Mina Morris Scott

You can tell that it is Christmas;
it is in the very air,
for its special scents and odors
send fragrance everywhere.

The piney smell of evergreens,
the pungent candle flame,
the scent of warm plum pudding,
everywhere it is the same.

Through the doors of every household
float aromas sweet and rare,
and you know that Christmas dinner
is in preparation there.

The spicy smell of gingerbread men,
of cinnamon and clove,
prove Grandma's Christmas cookies
have been taken from the stove.

The tangy scent of oranges,
of cranberries and plums,
can start to whet your appetite,
while from the kitchen comes

the savory smell of the turkey
as it crisps and then turns brown,
and the good sage dressing baking
sends its fragrance all around.

Oh! Half the fun of Christmas
is just to anticipate
that luscious Christmas dinner,
and mind you, don't be late!

Your Christmas Gift
H. Wilbur Carroll

I shopped throughout the autumn haze,
down through December's trail,
and even Christmas shopping days,
but all to no avail.

I saw some lovely Christmas gifts,
things that seemed ideal—
not toys or the frivolous kind that shifts,
but good and sound and real.

I wanted something that you could keep,
in time would not grow old;
something that would never fade.
"We have none," I was told.

And then I found a shopping place,
deep down within the heart,
where gifts are inexpensive but
of the very finest art.

So here it is: your Christmas gift,
the best I can afford.
The kind of gift I'd like to have,
should I take another's word.

A gift without those fussy thrills,
but as from that above;
the kind I'd like for you to have:
my friendship and my love.

Christmas Rush
Virginia Blanck Moore

"This year I simply shall not rush,"
each Christmastime I say.
"I'll cut down on the gifts I give
and the cards I send away.
Just this once I shall forego
my usual baking spree;
and since I'm planning quietness,
why not forget the tree?"

Each Christmastime I say these things,
but somehow every day
I see some gifts I just must buy
for dear ones far away.
The stack of cards grows by the hour;
where is that recipe?
And somehow it's not Christmastime
without a Christmas tree.

So every year I rush again,
right up to Christmas Day,
and I know within my inmost heart
this is the happiest way.

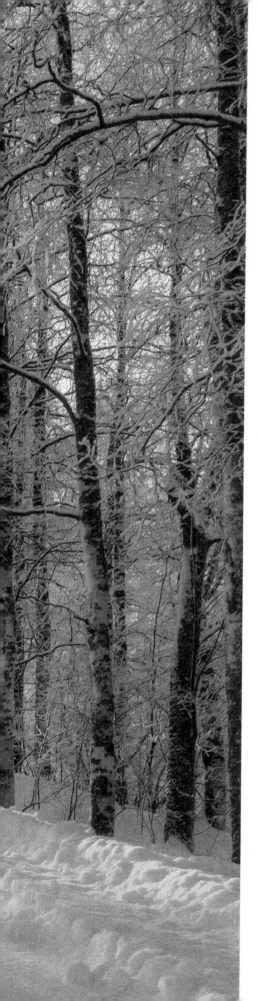

Winter Countryside

Elisabeth Weaver Winstead

A white, feathered snow has fallen
and covered the faded green,
as I make fresh, fragile footprints
in the snow-shimmered country scene.

As I walk the lane through winter
with gold autumn past and gone,
the world lies silver spindled
in the ice-crystal, country dawn.

The singing brook is silent,
frozen firm in winter's clasp,
hemmed in frost-laced stitchery
with ice-laden blades of grass.

The winter world is a sparkling land;
trees glisten in sequined artistry;
each dazzling crystal's wind-spun design
is ablaze with diamonds for all to see.

Velvet Shoes

Elinor Wylie

Let us walk in the
 white snow
in a soundless space;
with footsteps quiet and slow,
at a tranquil pace
under veils of white lace.

I shall go shod in silk,
and you in wool,
white as white cow's milk,
more beautiful
than the breast of a gull.

We shall walk through the
 still town
in a windless peace;
we shall step upon white down,
upon silver fleece,
upon softer than these.

We shall walk in velvet shoes;
wherever we go
silence will fall like dews
on white silence below.
We shall walk in the snow.

Winter Morning

Edna Jaques

A morning crisp as watered silk,
with blankets of new-fallen snow
tucking the little houses in
for fear their naked feet will show.
The trees and shrubs are beautiful,
wrapped in their coats of carded wool.

The children on their way to school,
in knitted caps and scarlet coats,
play hide-and-seek behind the drifts.
Their laughter rises high and floats
above the highest maple tree
like half-forgotten melodies.

The shop where Mother buys the bread
has glittering panes of frosted glass,
through which the lights take on a glow
like holy candles at a mass.
The streets are paved with softest down
as if a king had come to town.

A sleigh goes by with chiming bells,
young people riding for a lark;
their merry voices seem to ring
with extra sweetness in the dark
as if they tasted suddenly
how lovely simple things can be
when earth puts on her ermine wrap
and holds white diamonds in her lap.

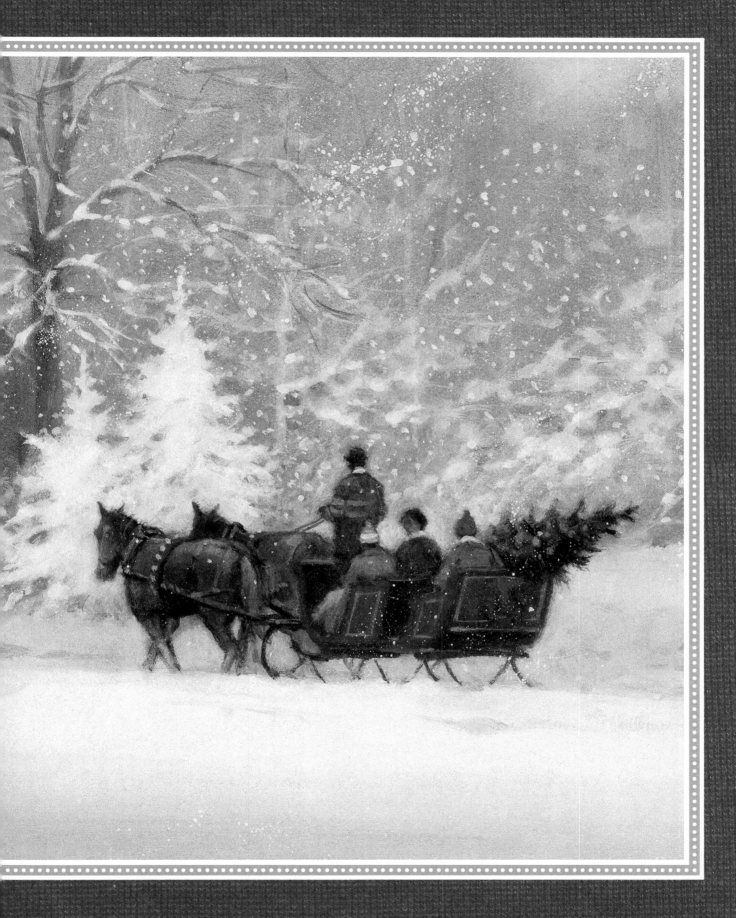

Sing a Song of Christmas

Lola Neff Merritt

Sing a song of Christmas,
sweet carols fill the air;
open up your heart
 with love
and drop life's daily cares.

Joyously lift up songs of praise
to our heavenly Father above;
who gave life's greatest
 gift of all,
His Son, who came in love.

How Grand and How Bright

Author Unknown

How grand and how bright that wonderful night
when angels to Bethlehem came;
they burst forth like fires and they strummed
 their stringed lyres
and mingled their sound with the flame.

The shepherds were amazed, the pretty lambs gazed
at darkness thus turned into light;
no voice was there heard, from man, beast, nor bird,
so sudden and solemn the sight.

And then when the sound reechoed around,
the hills and the dales all awoke;
the moon and the stars stopped their fiery cars
and listened while angels thus spoke:

"I bring you," said he, "from that glorious realm
a message both gladsome and good:
Our Savior is come to the world as His home,
but He lies in a manger of wood."

At mention of this, the Source of all bliss,
the angels sang loudly and long;
they soared to the sky, beyond mortal eye,
but left us the words of their song.

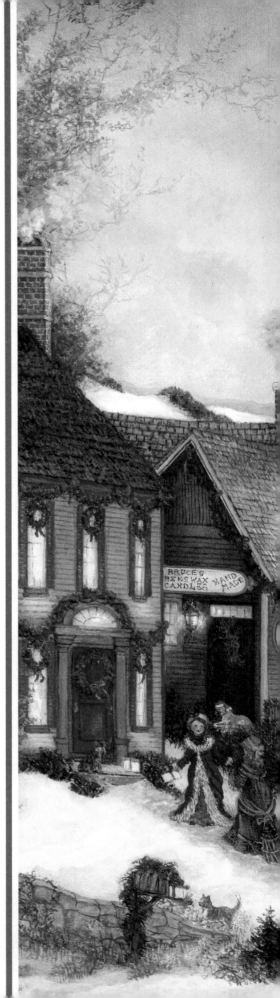

Carolers in Town Square *by Linda Nelson Stocks.*
Image © Linda Nelson Stocks/Courtney Davis Inc.

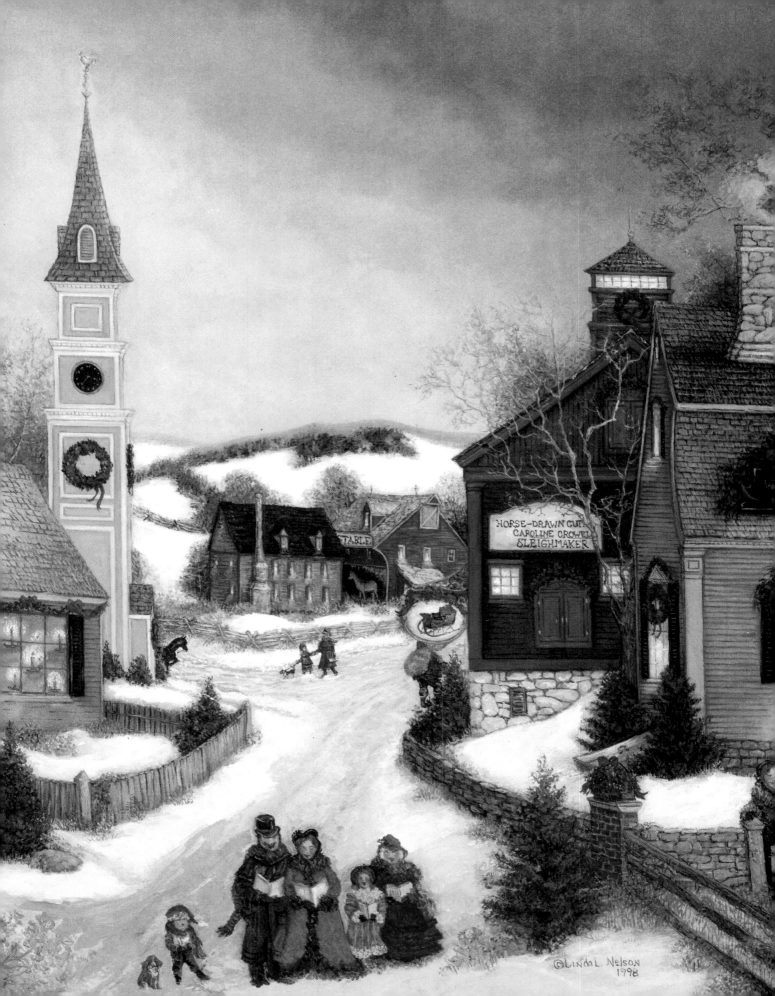

Christmas Caroling

Jewell Johnson

The five of us trudged down the path, our overshoes crunching softly on the snow-packed road. At the corner we stopped under a streetlight.

"Where should we go now?" Bobby asked.

No one spoke.

"How about Mr. Blake's?" Marilyn finally said.

Our eyes peered into the darkness to see the outline of the Blake mansion looming on the hill, a half mile from where we stood.

We had sung Christmas carols for the widow Sorvik, the Bengstons, Ben Nelson, and others nearby. It had never occurred to us to venture beyond our neighborhood and certainly not to sing for the proprietor of Blake's Dry Goods Store.

It wasn't that kids in our town didn't have plenty to do. We could have been ice-skating now that some kind person had hung a lightbulb over the pond. Or since it was Monday night, we could have been home listening to Lux Radio Theater. We also could have been reading Lincoln's Emancipation Proclamation for history class, but that was low on our list.

No, it wasn't boredom that sent us caroling on this subzero night a week before Christmas. We liked singing carols, and we knew all the songs by heart. For weeks we'd practiced "Silent Night," "Joy to the World," and others for church and school. Yet it was more than that. It was the magic of the season, the desire to share the joy of Christmas.

"It's pretty far up there," I said, studying the winding lane to the mansion.

"Yeah, and Mr. Blake's hard of hearing," Earl chimed in.

"Besides, he never goes to church," Bobby added. "He doesn't even like Christmas carols."

We had overheard our parents speculate on the reasons Mr. Blake didn't darken the church door. Some said it was because he was too deaf to hear the preacher. Others thought the town's only millionaire was excused from ordinary things like churchgoing.

"If we sing for him, maybe he'll give us a candy bar," Mary Ann's high-pitched voice pierced the night air. She patted her mittens together, pleased to come up with the idea.

Every child within twenty-five miles knew Mr. Blake often handed out free chocolate bars to children in his store on Saturdays. I had seen kids run from the John Deere Implement to Blake's in one minute to get in on the candy.

So that night, the five of us started up the snow-packed lane.

The Blake mansion stood apart from town, situated on five acres. Surrounded by giant cottonwoods, elms, and maples, the bare branches creaked and swayed in the night. Snow-covered hedges stood like white sentinels in the pale starlight.

When we got closer, we saw only a few lights on. "Do you think he'll hear us?" Bobby asked, raising his eyes to the window above us.

"No, but Mrs. Rustad, his housekeeper, will," I said.

We stood knee-deep in snow and sang, "O little town of Bethlehem, how still we see thee lie."

When the last note faded, we waited, expecting to see a face at the window. No one appeared.

"Let's try 'Joy to the World,'" Bobby said, stomping his feet to keep warm. "We can get loud on that one."

We strained our voices, all the while craning our necks for a glimpse of Mr. Blake at the window.

"He can't hear us," I sighed. We turned to find our way back to the road.

"Children! Children! Would you like to come in and sing for Mr. Blake?" Mrs. Rustad appeared in the shadows, hugging a pink sweater around her checkered housedress.

"Yes!" we shouted. Hopping over the snow-drifts like arctic kangaroos, we pushed our way toward the back entrance of the mansion.

Mrs. Rustad led us into a small, unheated room. "Wait here," she said.

Looking around we saw Mr. Blake's eight-buckle overshoes standing on the green linoleum.

Soon the door swung open, and the older man, in a gray suit and vest, stepped into the room. "You came to sing for me?" he asked. His stern, gray eyes swept over the five of us. We nodded.

"What are your names?" He pointed a finger at Bobby.

"Bobby Carlson. This is my little sister. She's six." He nodded toward Mary Ann.

"Speak louder, children," Mrs. Rustad said. "Mr. Blake is hard of hearing.

"Earl's my name," Earl shouted. "And this is Marilyn and Jewell." He motioned toward us.

Mr. Blake adjusted his hearing aid, cupped a hand over his ear, and fixed his eyes on the linoleum. It was time to sing. "Joy to the world! The Lord is come!" We sang with all our might. Then, softer, we sang "Silent Night" and "O Little Town of Bethlehem." As the music faded, Mrs. Rustad wiped her eyes. Mr. Blake cleared his throat and shifted his feet, but his eyes did not meet our gaze.

No one moved. Finally, Bobby said, "Well, we'll be going." Four of us shuffled toward the door. Unmoving, Mary Ann stared at Mr. Blake, her blue eyes round as marbles.

Suddenly Mr. Blake leaped into action. "Wait!" he shouted. "Wait just a minute." He disappeared through the door.

We looked at Mrs. Rustad, then at Mr. Blake's overshoes until we heard footsteps and Mr. Blake sprang into the room. In his hand he held a brown box. Ah! Candy bars!

Mary Ann smiled as she selected a chocolate bar. "Thank you!" she shouted loud enough for Mr. Blake to hear.

As each of us thanked him, we couldn't have been happier if we'd been presented with a new toboggan or sled. Outside, we took off our mittens and carefully unwrapped the candy.

"Wasn't that nice of him?" Mary Ann's shrill voice echoed in the stillness. "I sure like Mr. Blake."

"Let's sing!" Bobby yelled. "Joy to the world! The Lord is come." He waved his arms in the air.

We joined in: "Let every heart prepare Him room. And heav'n and nature sing." The words echoed through the dark streets, resounding even in the heart of our town's millionaire, Mr. Blake.

My Library Fireplace

Frances Parkinson Keyes

My library fireplace is wide;
its shining brasses glow;
the easy chairs on either side
are comfortable and low.

Secure and strong the
 hearthstone lies
beyond the deep-set grate,
and marble columns
 smoothly rise
to frame the hearth in state.

The mantel shelf is marble too,
a painting hangs above it—
if you should see my library, you,
like me, would come to love it.

On rainy days and chilly days
the fire burns warm and bright,
and when the darkness
 falls, it plays
in lovely leaping light.

But once a year on
 Christmas Eve,
stripped clear of logs and brasses,
it is made ready to receive
the little lambs and asses,

the quiet cows, the gentle sheep
that gather round a manger;

where angels guard
 a Baby's sleep
and ward away all danger.

Bemused and meek
 Saint Joseph stands
near Wise Men from afar;
and Mary kneels,
 with folded hands,
beneath a shining star.

And all the beauty,
 all the light
embodied in the story
of Christmas Eve is
 here, so bright,
the room reflects its glory.

So come and share my
 hearth and home
as often as you're able,
on gloomy days and
 cold—and come
to see my sacred stable,

glad with the confidence
 that then
together we'll receive
the blessing of goodwill to men
that comes on Christmas Eve.

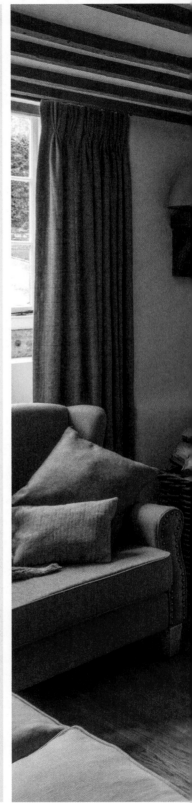

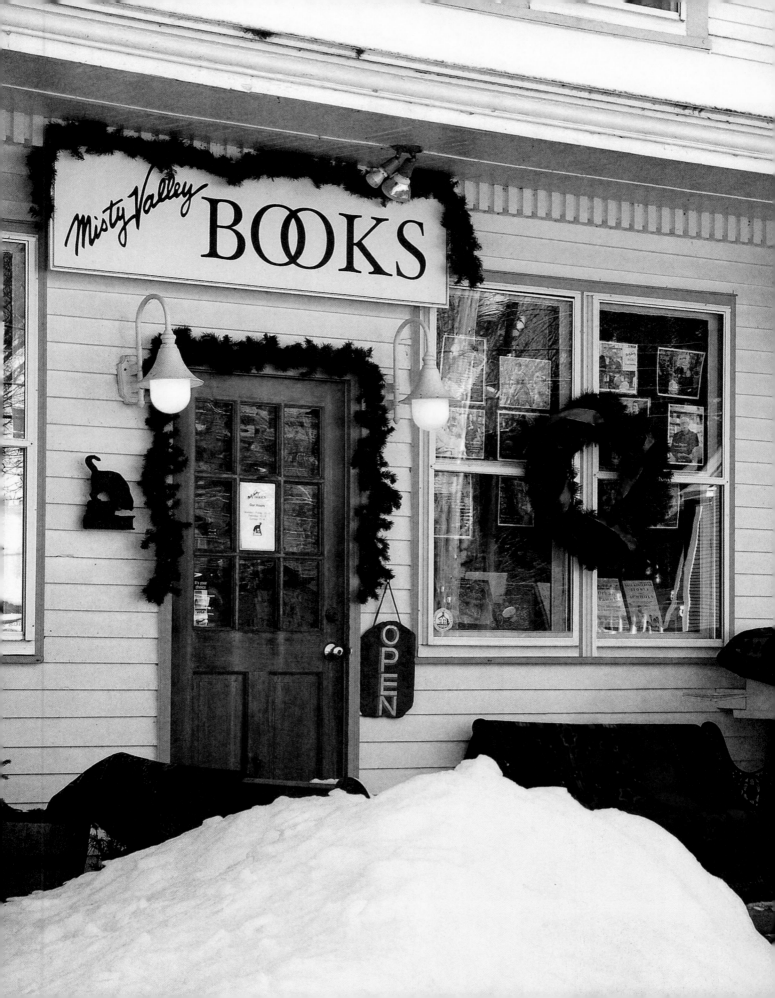

A Tradition of Books

Eileen Spinelli

Even before I learned to read, I fell in love with books. Merrily, I would pull my parents' books from the bottom shelves of the bookcase and build a boat for myself and my teddy bear. Sometimes I played library with my dolls—pretending to read to them, shushing them if they got too rowdy.

When at last I did learn to read, I fell in love even more. Growing up I asked for books for birthdays and Christmas: *Pollyanna*, *Anne of Green Gables*, *Little Women*.

As an adult there were lean times. I cherished the town library. And my free library card. Also, the local thrift shops that sold books for only fifty cents apiece. I filled my own bookshelves: novels, poetry, cookbooks, gardening, theology, psychology, humor. No Christmas was complete without Charles Dickens's *A Christmas Carol* or Barbara Robinson's *The Best Christmas Pageant Ever* or *The Gift of the Magi* by O. Henry.

Books have always been at the top of my Christmas wish list. I once tried to make a Christmas tree of books. Alas, it toppled. So you can imagine how enchanted I was when I learned about the Icelandic tradition of gifting books on Christmas Eve. This custom dates back to World War II, when many items were scarce. Except for paper. And so books became the Icelanders' gift of choice.

But wait—the tradition is even sweeter. On Christmas Eve, the idea is to spend the evening with friends, family, or a single loved one reading your new books together. Perhaps sipping hot chocolate in front of a fire. If you don't have a fireplace, cozying up with your favorite sweater or blanket will do just fine.

My bookish heart will definitely be borrowing this beautiful Christmas tradition. Off I go to our local bookstore with list in hand.

Gleðileg jól, everyone!

Bookstore in Chester, Vermont. Image © Kirkikis/iStock

The Perfect Gift

Mary Wells

The Christmas tree is set up with care,
and the scent of pine is in the air;
its branches green are dusted white,
covered all over with tinsel and lights.

We've been shopping by day and searching
 by night,
trying to get the best gift in sight.
We are wrapping each box with paper and bows,
what's in each package, nobody knows.

There's joy in the air, the carolers are singing,
the kids all know that gifts we'll be bringing.
There are secrets tucked beneath the tree,
waiting there for all to see.

But the perfect gift doesn't come from the earth,
it came from God in a heavenly birth.
They heard from angels, they sought Him by star,
the Wise Men and shepherds came from afar.

They bowed low and worshiped our Lord and
 our King,
gave Him honor and glory and every good thing.
All heaven came down in our Savior that day.
He is Lord, the Messiah, the Truth, and the Way.

The gift of all ages was God's perfect plan;
in a holy Child He came to man.
Prophets foretold it, many times, many ways,
and it came to pass on that first Christmas Day.

Let us sing His praises, let our voices resound,
rejoice in the Lord, we are heaven bound.
All blessing and honor and glory and praise
we give to our Savior the rest of our days.

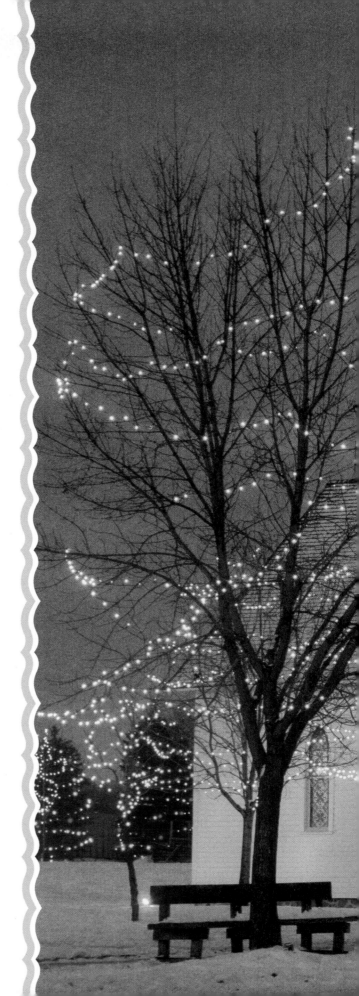

Church near Flint, Michigan. Image © H. G. Ross/SuperStock

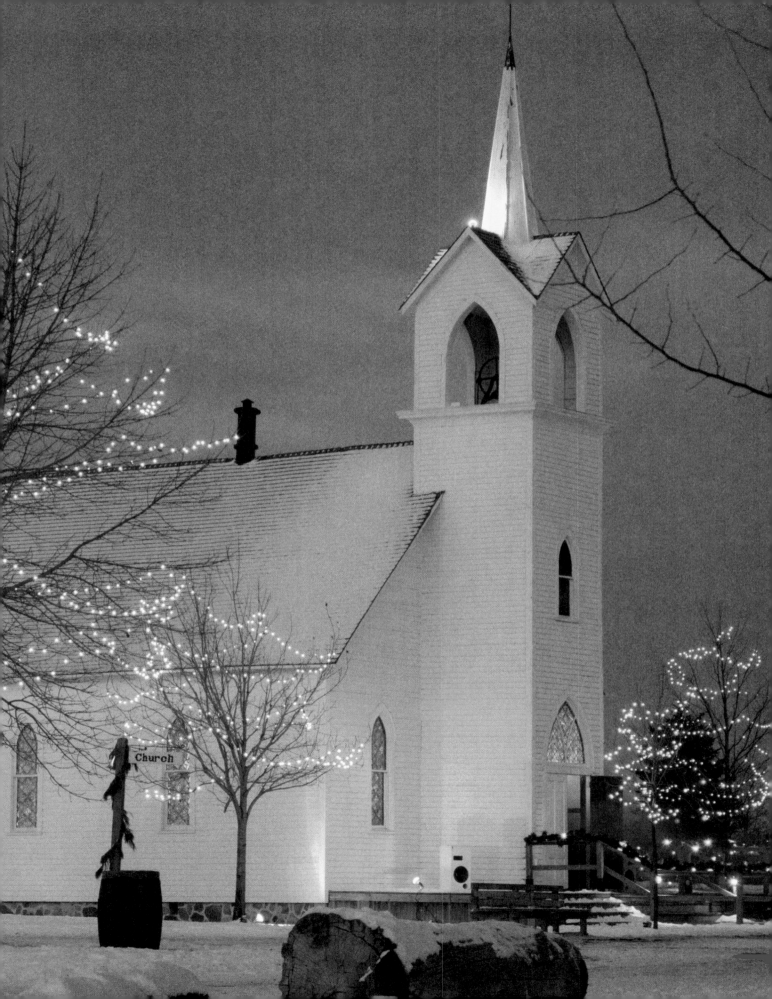

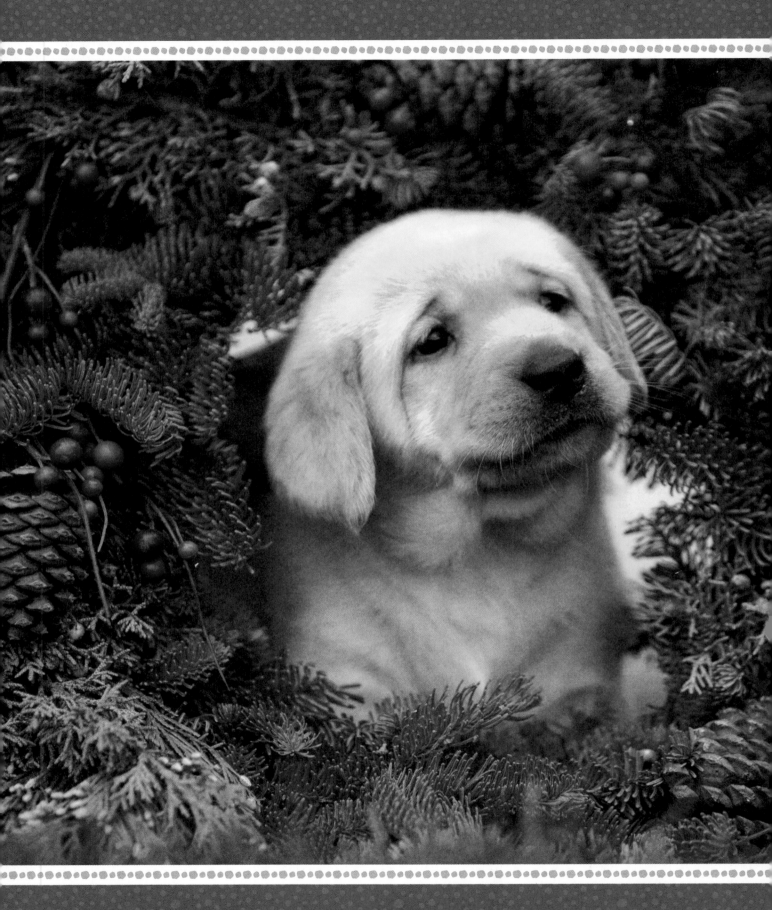

Dear Santa

Patricia Pingry

Dear Santa,
Please bring me
a puppy for Christmas—
a little white puppy;

a puppy with a tail that wags
and with a cold black nose;
a puppy who can fetch
and who will "sit" or "come."

Dear Santa,
please bring me a puppy
who will wait while I am gone
and love to have me back.

Bring me a puppy
who'll be happy
when I'm happy
and sad when I am sad.

Please Santa,
bring me a puppy
who stays by my side all day
and by my bed all night.

Dear Santa,
I'll feed my puppy every day
and keep her water filled.

When she's been good,
I'll give her treats.
Then she'll be good for me.

Dear Santa,
I've been good
this whole year through.

So Santa, sir,
please bring me my puppy.

Yes, Virginia, There Is a Santa Claus

DEAR EDITOR: *I am 8 years old. Some of my little friends say there is no Santa Claus. Papa says, "If you see it in 'The Sun,' it's so." Please tell me the truth: Is there a Santa Claus?*
—VIRGINIA O'HANLON, 115 WEST NINETY-FIFTH STREET

Virginia, your little friends are wrong. They have been affected by the skepticism of a skeptical age. They do not believe except they see. They think that nothing can be which is not comprehensible by their little minds. All minds, Virginia, whether they be men's or children's are little. In this great universe of ours, man is a mere insect, an ant, in his intellect, as compared with the boundless world about him, as measured by the intelligence capable of grasping the whole of truth and knowledge.

Yes, Virginia, there is a Santa Claus. He exists as certainly as love and generosity and devotion exist, and you know that they abound and give to your life its highest beauty and joy. Alas! how dreary would be the world if there were no Santa Claus. It would be as dreary as if there were no Virginias. There would be no childlike faith then, no poetry, no romance to make tolerable this existence. We should have no enjoyment, except in sense and sight. The eternal light with which childhood fills the world would be extinguished.

Not believe in Santa Claus! You might as well not believe in fairies! You might get your papa to hire men to watch in all the chimneys on Christmas Eve to catch Santa Claus, but even if they did not see Santa Claus coming down, what would that prove? Nobody sees Santa Claus, but that is no sign that there is no Santa Claus. The most real things in the world are those that neither children nor men can see. Did you ever see fairies dancing on the lawn? Of course not, but that's no proof that they are not there. Nobody can conceive or imagine all the wonders there are unseen and unseeable in the world.

You may tear apart the baby's rattle and see what makes the noise inside, but there is a veil covering the unseen world which not the strongest man, nor even the united strength of all the strongest men that ever lived, could tear apart. Only faith, fancy, poetry, love, romance can push aside that curtain and view and picture the supernal beauty and glory beyond. Is it all real? Ah, Virginia, in all this world there is nothing else real and abiding.

No Santa Claus! A thousand years from now, Virginia, nay, ten times ten thousand years from now, he will continue to make glad the heart of childhood.

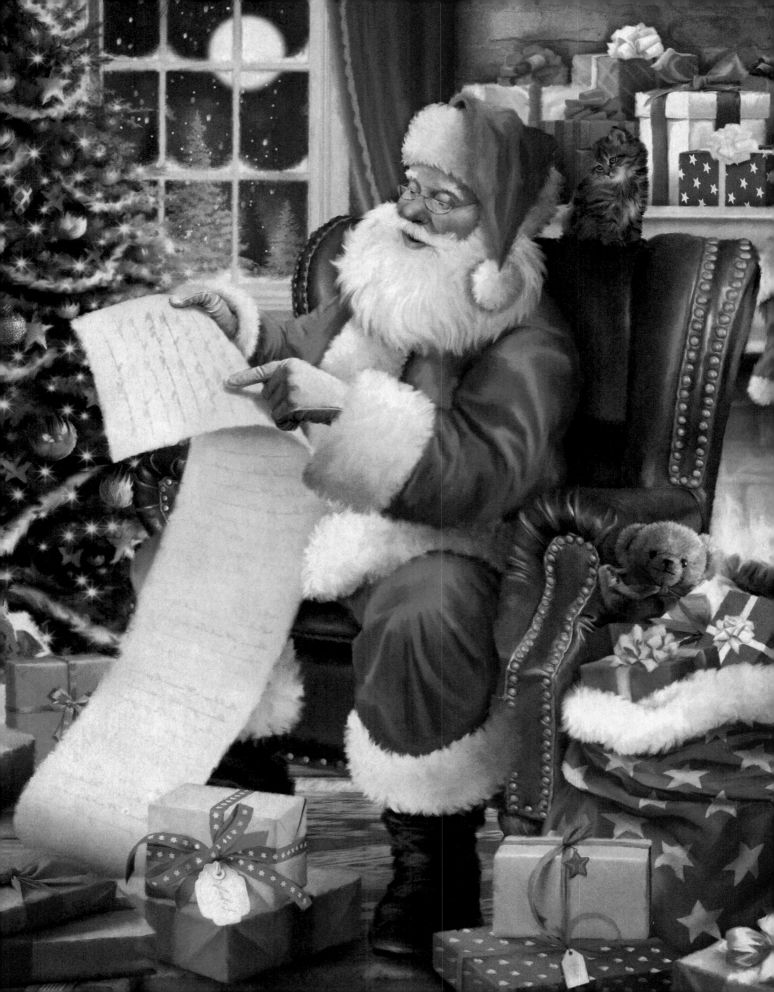

For Our Children

Peter Marshall

*L*ord Jesus, who didst take little children into Thine arms and laugh and play with them, bless, we pray Thee, all children at this Christmastide. As with shining eyes and glad hearts they nod their heads so wisely at the stories of the angels, and of a Baby cradled in the hay at the end of the way of a wandering star, may their faith and expectation be a rebuke to our own faithlessness.

Help us to make this season all joy for them, a time that shall make Thee, Lord Jesus, even more real to them. Watch tenderly over them and keep them safe. Grant that they may grow in health and strength into Christian maturity. May they turn early to Thee, the Friend of children, the Friend of all. We ask in the lovely name of Him who was once a little child. Amen.

Children

Winnie Barnett

Give me your rosy-cheeked children
for one December day,
for it doesn't seem like Christmas
when they've grown and
 moved away.

Let me see the merry twinkle
in their big expectant eyes;
let me hear the lilting laughter
as they plan a wee surprise.

Let me sense their same excitement
and wonder of it all;
let me see the sights of Christmas
through the eyes of a child
 so small.

Let me thrill to the sound of
 their voices
as they sing a carol sweet;
and see their bewildered faces
when Santa they chance to meet.

Let me kneel with them at
 the manger
as they worship the newborn King
and eagerly follow their footsteps
when Christmas bells begin to ring.

Lord, give me the faith of children
and a loving heart like theirs:
serene and humbly trusting
in Thy heavenly care.

The Perfect Excuse

Anne Kennedy Brady

I've never been crafty. I've tried. In high school, I got serious about scrapbooking. In college, someone taught me to knit. After graduation, I tried my hand at sewing. Nothing lasted more than a year or two. Then at some point, I discovered baking. It turns out I don't hate crafts—I just need to be able to eat them. And Christmas is, hands down, the best time for baking.

A few Christmases ago, I decided it was time to introduce my son to the magic of Christmas cookies. I harbored visions of sharing a sun-dappled kitchen with my cherubic four-year-old, wooden spoons in hand, a bit of flour dusting our laughing faces. I would create a memory certain to follow him straight into adulthood, a tender reminder of a perfect childhood. So one chilly Saturday at the end of November, I put the baby down for a nap, flipped on the Christmas music, pulled out the ingredients for my favorite gingerbread cookies, and got Milo settled on a step stool.

"The first thing we need to do is measure the flour. Take this spoon . . ." and therein ended the lesson. First, he dug the spoon too deep and catapulted a powdery cloud into the air and snowy piles onto the floor and counter. While we cleaned it up, he discovered that he loved the flour's velvety softness—so he plunged his hand directly into the canister. I screeched, and he yanked his hand back, leading to more clouds, more piles. Things did not improve. When leveling the sugar, he wielded the butter knife like a ninja sword, sending the excess skittering across the counter. Instead of using the back of his spoon to pack the brown sugar into a measuring cup, he used the front of the spoon to pack it into his mouth. A finger-full of butter ended up in there, too, as did ground cinnamon, which he licked off the counter after knocking over the jar. The coughing fit that followed made him slip off the step stool. I caught him in time to prevent serious injury, but he did bonk his elbow and we had to stop for a bandage.

By the time the cookies were in the oven, neither of us felt particularly full of holiday cheer, and the kitchen looked like a crime scene. We each ate a cookie in silence as soon as the first batch was out of the oven. Then the baby woke up. I scrapped my now ludicrous idea of making royal icing from scratch. Instead, I spread glops of canned frosting on each cookie and let Milo dump rainbow sprinkles on each one. Merry Christmas.

About a week later, brooding over photos of perfectly decorated Christmas cookies, I got an email from a friend across the country. Would I like to join her and her daughters for an online class to decorate gingerbread houses the following Sunday? My eye started to twitch. But the last line of her email caught me: "It's a good excuse to get us all together."

I breathed out. She was exactly right. In fact, I thought, most traditions are really just good excuses. Hanging lights and ornaments is an excuse to make something beautiful with those you love. Exchanging presents is an excuse to appreciate

others. Even Christmas cookies—they're just an excuse to make a delicious mess with someone you treasure. No one needs royal icing.

So I said yes. I bought a kit that included a pre-assembled gingerbread house, a tube of white icing, and six small bags of various candies. We logged on at the appointed time to listen to the teacher read "The Gingerbread Man" and decorated along with our friends. Yes, less than half of the candies ended up on the house. And sure, our candy house looked like a frightening "before" photo from one of those home makeover shows. But my friend and I laughed together and traded inside jokes and wiped our kids' sticky hands and snuck some candy when they weren't looking. It was, indeed, a great excuse to get together. And a delicious one, too!

Delicious Gingerbread Cookies

10	tablespoons butter, softened		1	tablespoon ground ginger
¾	cup brown sugar		1	tablespoon ground cinnamon
⅔	cup molasses		1	teaspoon baking soda
1	egg, room temperature		½	teaspoon salt
1	teaspoon vanilla extract		½	teaspoon ground allspice
3½	cups all-purpose flour		½	teaspoon ground cloves

In the bowl of a stand mixer with paddle attachment, beat the butter on medium speed until smooth and creamy, about 1 minute. Add brown sugar and molasses; beat on medium-high speed until well combined. Scrape bowl as needed. Add egg and vanilla; beat on high speed for 2 full minutes, scraping bowl as needed. In a medium bowl, whisk together remaining ingredients. On low speed, slowly add dry ingredients to wet mixture until combined. Dough will be thick and sticky. Divide dough in half. Wrap each half tightly in plastic wrap and pat down to create a disc shape. Chill dough for at least 3 hours and up to 3 days.

Preheat oven to 350°F. Line 2 or 3 large baking sheets with parchment paper or silicone baking mats. Remove 1 disc of chilled cookie dough from the refrigerator. Generously flour a work surface, as well as your hands and rolling pin. Roll out dough to ¼ inch thick. Cut into shapes with 4-inch cutters. Place cookies 1 inch apart on prepared baking sheets. Repeat with remaining dough. Bake about 9 to 10 minutes. Cool 5 minutes on the cookie sheet then transfer to rack. When completely cool, decorate as desired. Store in airtight container. Makes 2 dozen 4-inch cookies.

Family Recipes

Candy Cane Cookies

1 cup plus 2 tablespoons sugar
1 cup butter, softened
½ cup milk
1 teaspoon vanilla extract
1 teaspoon peppermint extract
1 large egg

3½ cups all-purpose flour
1 teaspoon baking powder
¼ teaspoon salt
½ teaspoon red food coloring
2 tablespoons finely crushed
 peppermint candies

In a large mixing bowl, combine 1 cup sugar, butter, milk, vanilla and peppermint extracts, and egg; mix well. Stir in flour, baking powder, and salt. Divide dough in half. Stir food coloring into one half. Cover and refrigerate at least 4 hours.

Preheat oven to 375°F. Stir together peppermint candy and 2 tablespoons sugar; set aside. For each candy cane, shape 1 rounded teaspoon dough from each half into 4-inch ropes by rolling back and forth on floured surface. Place 1 red and 1 white rope side by side; press together lightly and twist. Place on ungreased cookie sheet, curving top of cookie down to form the handle of a cane. Bake 9 to 12 minutes or until light golden. Immediately sprinkle candy mixture over cookies. Remove from cookie sheet to wire rack and cool completely. Makes 4½ dozen candy canes.

Hot Mulled Cider

1 tablespoon whole cloves
1 tablespoon whole allspice
1 gallon apple cider or apple juice

3 cinnamon sticks
1 orange, sliced into
 ¼-inch-thick rounds

Wrap whole cloves and allspice in a square of cheesecloth and tie with string. In a Dutch oven or a large slow cooker, combine apple cider, spices, and cinnamon sticks. Add half of the orange slices. Heat to boiling; reduce heat and simmer for 15 minutes, stirring occasionally. Remove spices and oranges and ladle into mugs. Use remaining orange slices as garnish. Makes 16 1-cup servings.

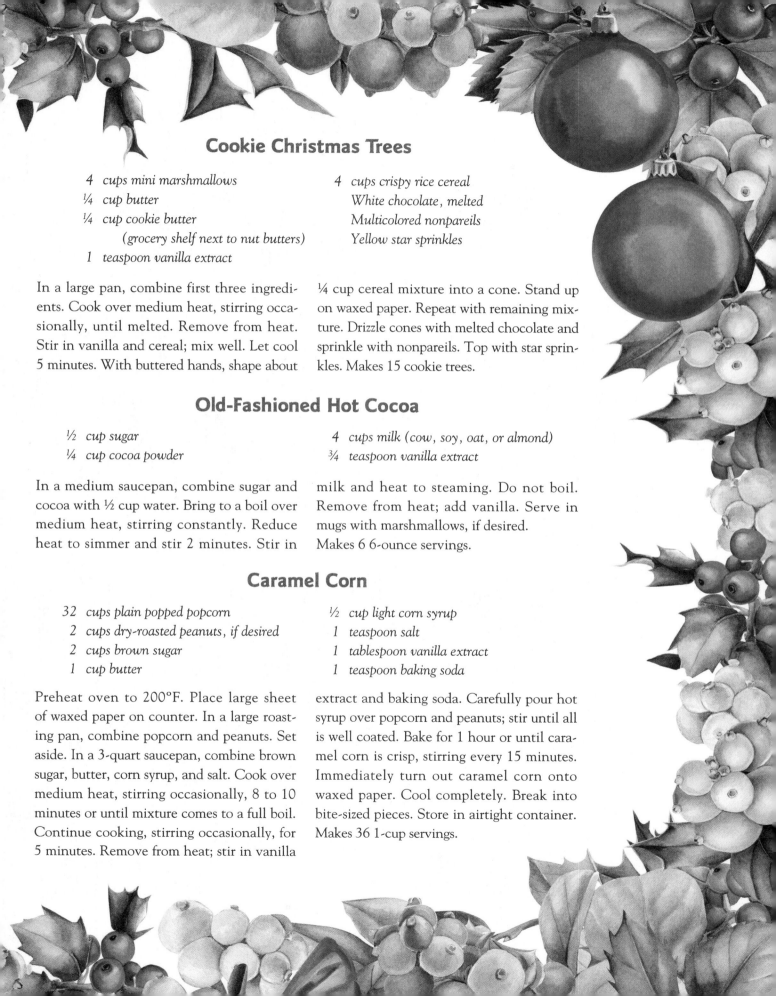

Cookie Christmas Trees

- 4 cups mini marshmallows
- ¼ cup butter
- ¼ cup cookie butter
 (grocery shelf next to nut butters)
- 1 teaspoon vanilla extract

- 4 cups crispy rice cereal
 White chocolate, melted
 Multicolored nonpareils
 Yellow star sprinkles

In a large pan, combine first three ingredients. Cook over medium heat, stirring occasionally, until melted. Remove from heat. Stir in vanilla and cereal; mix well. Let cool 5 minutes. With buttered hands, shape about ¼ cup cereal mixture into a cone. Stand up on waxed paper. Repeat with remaining mixture. Drizzle cones with melted chocolate and sprinkle with nonpareils. Top with star sprinkles. Makes 15 cookie trees.

Old-Fashioned Hot Cocoa

- ½ cup sugar
- ¼ cup cocoa powder

- 4 cups milk (cow, soy, oat, or almond)
- ¾ teaspoon vanilla extract

In a medium saucepan, combine sugar and cocoa with ½ cup water. Bring to a boil over medium heat, stirring constantly. Reduce heat to simmer and stir 2 minutes. Stir in milk and heat to steaming. Do not boil. Remove from heat; add vanilla. Serve in mugs with marshmallows, if desired. Makes 6 6-ounce servings.

Caramel Corn

- 32 cups plain popped popcorn
- 2 cups dry-roasted peanuts, if desired
- 2 cups brown sugar
- 1 cup butter

- ½ cup light corn syrup
- 1 teaspoon salt
- 1 tablespoon vanilla extract
- 1 teaspoon baking soda

Preheat oven to 200°F. Place large sheet of waxed paper on counter. In a large roasting pan, combine popcorn and peanuts. Set aside. In a 3-quart saucepan, combine brown sugar, butter, corn syrup, and salt. Cook over medium heat, stirring occasionally, 8 to 10 minutes or until mixture comes to a full boil. Continue cooking, stirring occasionally, for 5 minutes. Remove from heat; stir in vanilla extract and baking soda. Carefully pour hot syrup over popcorn and peanuts; stir until all is well coated. Bake for 1 hour or until caramel corn is crisp, stirring every 15 minutes. Immediately turn out caramel corn onto waxed paper. Cool completely. Break into bite-sized pieces. Store in airtight container. Makes 36 1-cup servings.

Light a Candle

Gladys Wellman

As twilight falls on
 Christmas Eve,
in your window place a light,
or candle, so the glow will shine
clear and piercing
 through the night.

And in my window,
 too, there'll be
a light shining steady and true
with a beam of friendship
 and of love
straight from my heart to you.

Not Forgotten

Helen Welshimer

I shall place white lights
on every windowsill:
one to face the roadway
and one to light the hill;

for I have read a story
which says there was no light
in any house in Bethlehem
that other Christmas night.

Oh, should He come a'wandering
this night, the Christ must see
that when I hung the stockings
and trimmed the Christmas tree,

I turned a shining moment
from revelry and din
to place a gracious welcome
in case He passed my inn.

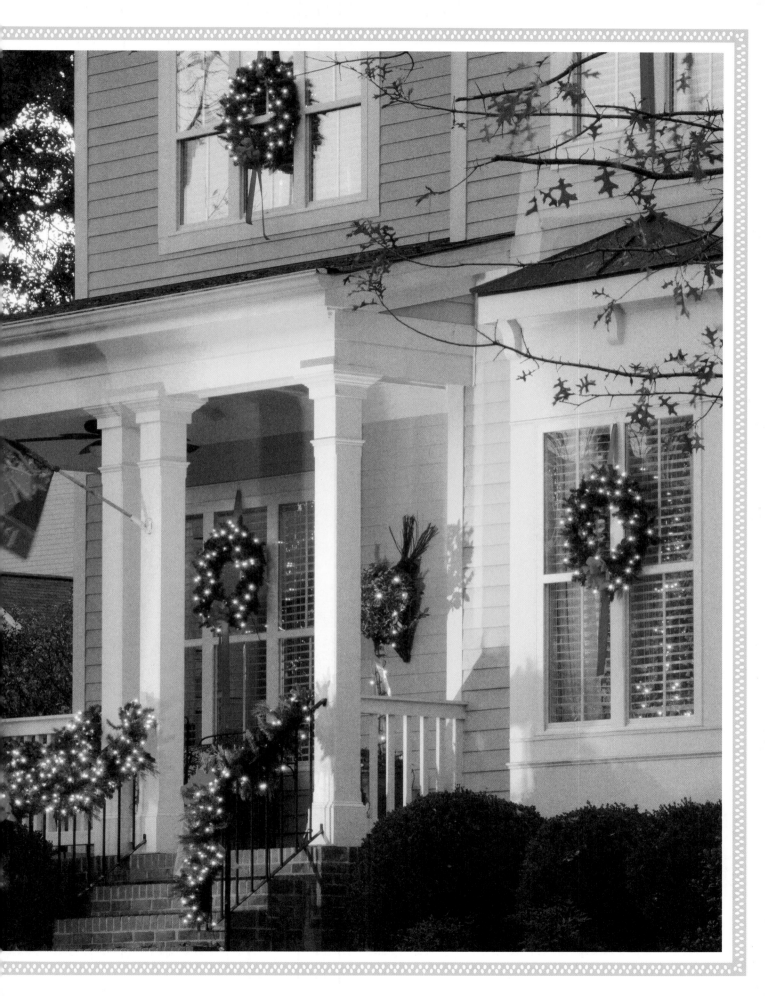

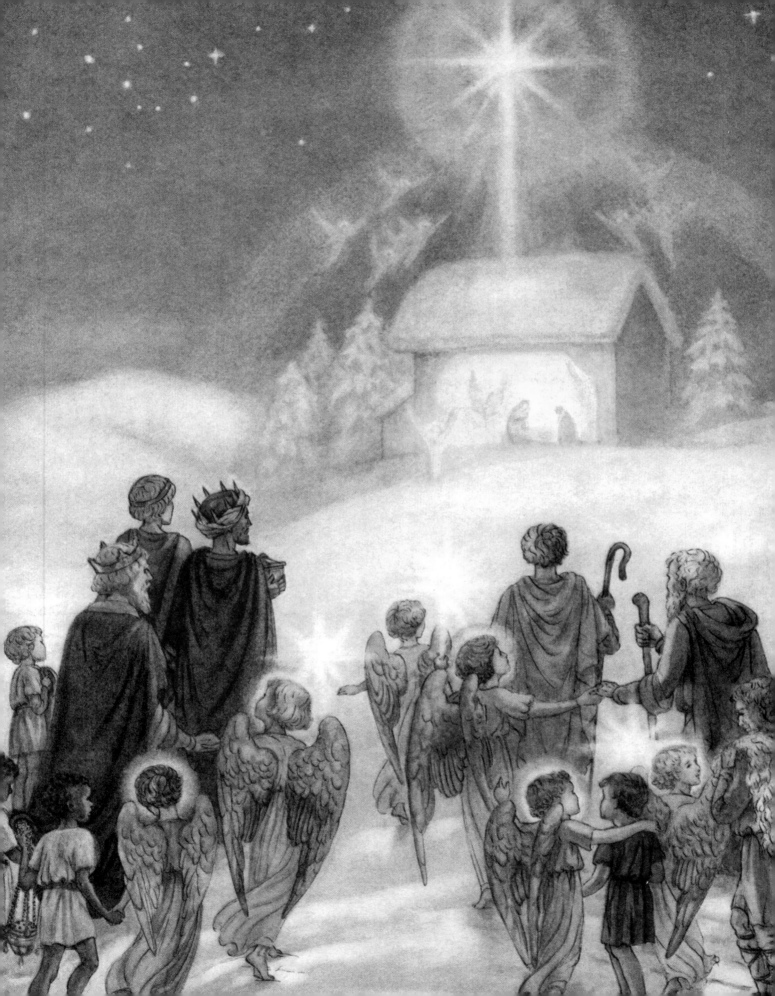

A Nativity Song
Frances Chesterton

How far is it to Bethlehem?
Not very far.
Shall we find the stable room
lit by a star?

Can we see the little Child;
is He within?
If we lift the wooden latch,
may we go in?

May we stroke the creatures there,
ox, ass, or sheep?
May we peep like them and see
Jesus asleep?

If we touch His tiny hand,
will He awake?

Will He know we've come so far
just for His sake?

Great kings have precious gifts
and we have naught;
little smiles and little tears
are all we brought.

For all weary children
Mary must weep;
here, on His bed of straw,
sleep, children, sleep.

God in His mother's arms,
babes in the byre, sleep,
as they sleep who find
their heart's desire.

O Little Town of Bethlehem
Phillips Brooks

O little town of Bethlehem,
how still we see thee lie!
Above thy deep and dreamless sleep
the silent stars go by;
yet in thy dark streets shineth
the everlasting light.
The hopes and fears of all the years
are met in thee tonight.

How silently, how silently,
the wondrous gift is giv'n!
So God imparts to human hearts
the blessings of his heav'n.

No ear may hear his coming,
but in this world of sin,
where meek souls will receive him, still
the dear Christ enters in.

O holy Child of Bethlehem,
descend to us, we pray,
cast out our sin and enter in,
be born in us today.
We hear the Christmas angels
the great glad tidings tell;
O come to us, abide with us,
our Lord Immanuel!

The Nativity
C. S. Lewis

Among the oxen (like an ox I'm slow)
I see a glory in the stable grow
which, with the ox's dullness, might
 at length
give me an ox's strength.

Among the asses (stubborn I as they)
I see my Saviour where I looked for hay;
so may my beastlike folly learn at least
the patience of a beast.

Among the sheep (I like a sheep
 have strayed)
I watch the manger where my Lord
 is laid;
oh that my baa-ing nature would
 win thence
some woolly innocence!

The Oxen
Thomas Hardy

Christmas Eve, and twelve
 of the clock.
"Now they are all on their knees,"
an elder said as we sat in a flock
by the embers in hearthside ease.

We pictured the meek, mild
 creatures where
they dwelt in their strawy pen,
nor did it occur to one of us there
to doubt they were kneeling then.

So fair a fancy few would weave
in these years! Yet, I feel,
if someone said on Christmas Eve,
"Come, see the oxen kneel,

"in the lonely barton
 by yonder coomb
our childhood used to know,"
I should go with him
 in the gloom,
hoping it might be so.

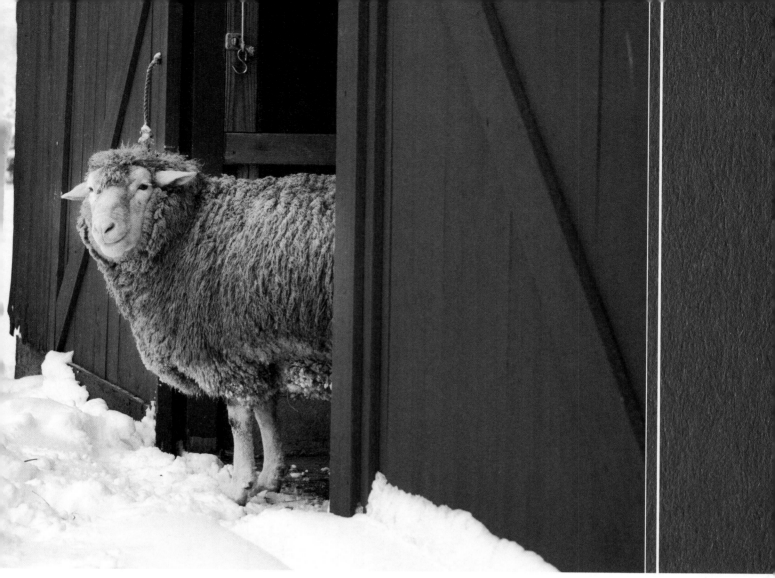

Image © Cavan Images/AdobeStock

Only an Hour

Robinson Jeffers

For an hour on Christmas Eve
and again on the holy day,
seek the magic of past time,
from this present turn away.
Dark though our day,
light is the snow on the hawthorn bush,
and the ox knelt down at midnight.

Only an hour, only an hour,
from wars and confusions turn away
to the islands of old time

when the world was simple and gay,
or so we say,
and light lay the snow on the green holly,
the tall oxen knelt at midnight.

Caesar and Herod shared the world,
sorrow over Bethlehem lay,
iron the empire, brutal the time,
dark was the day,
light lay the snow on the mistletoe berries
and the ox knelt down at midnight.

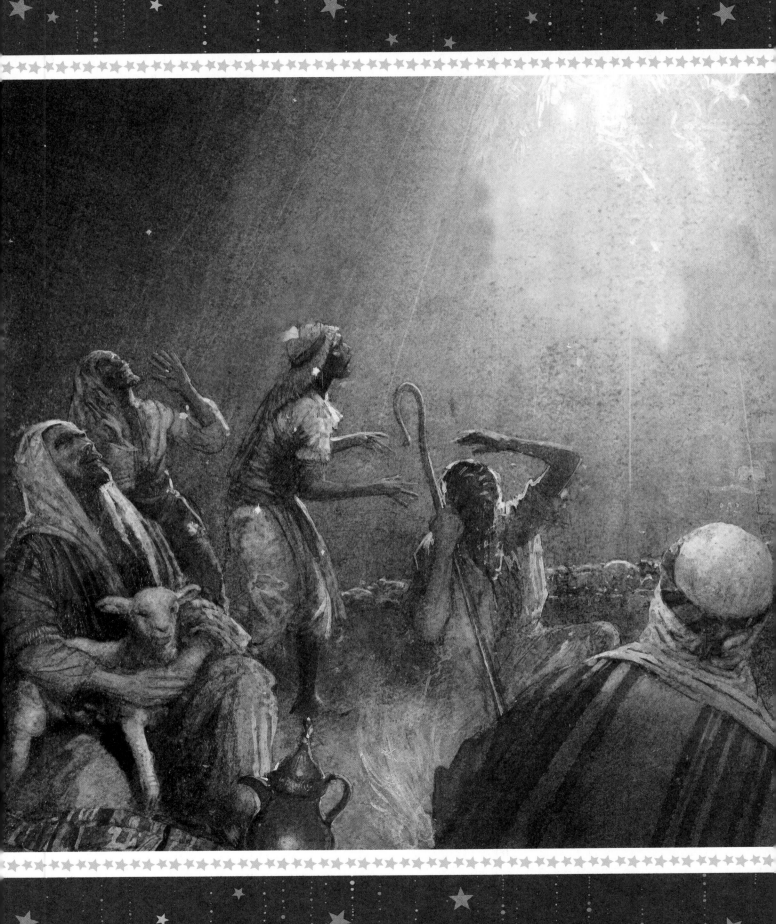

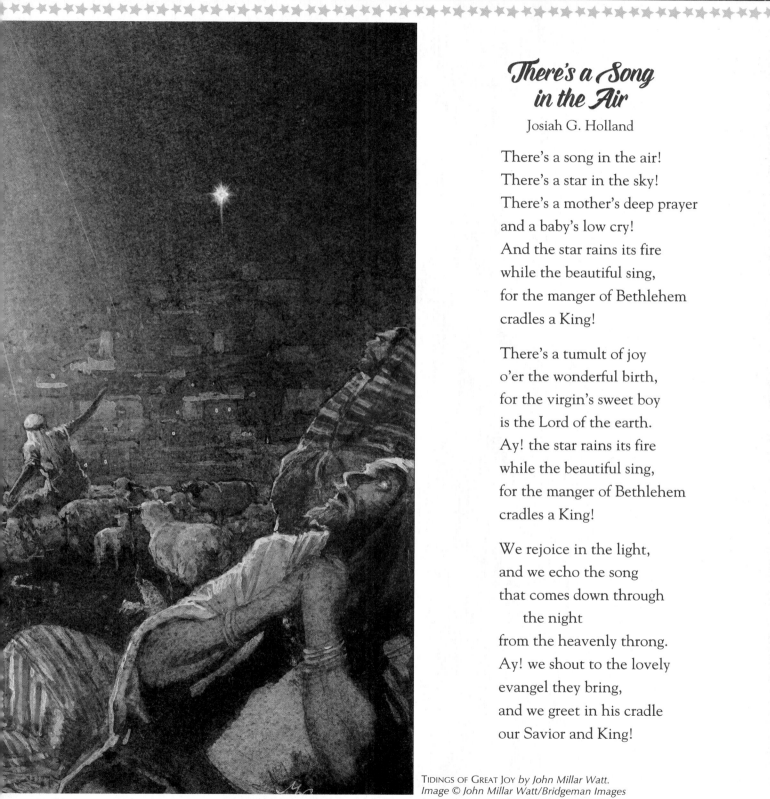

There's a Song in the Air

Josiah G. Holland

There's a song in the air!
There's a star in the sky!
There's a mother's deep prayer
and a baby's low cry!
And the star rains its fire
while the beautiful sing,
for the manger of Bethlehem
cradles a King!

There's a tumult of joy
o'er the wonderful birth,
for the virgin's sweet boy
is the Lord of the earth.
Ay! the star rains its fire
while the beautiful sing,
for the manger of Bethlehem
cradles a King!

We rejoice in the light,
and we echo the song
that comes down through
 the night
from the heavenly throng.
Ay! we shout to the lovely
evangel they bring,
and we greet in his cradle
our Savior and King!

TIDINGS OF GREAT JOY *by John Millar Watt.*
Image © John Millar Watt/Bridgeman Images

"Therefore the Lord himself will give you a sign. Behold, the virgin shall conceive and bear a son, and shall call his name Immanuel."

—Isaiah 7:14

The Birth

Matthew 1:18–21, 24–25; Luke 2:1–7

Now the birth of Jesus Christ took place in this way. When his mother Mary had been betrothed to Joseph, before they came together she was found to be with child from the Holy Spirit. And her husband Joseph, being a just man and unwilling to put her to shame, resolved to divorce her quietly. But as he considered these things, behold, an angel of the Lord appeared to him in a dream, saying, "Joseph, son of David, do not fear to take Mary as your wife, for that which is conceived in her is from the Holy Spirit. She will bear a son, and you shall call his name Jesus, for he will save his people from their sins."

When Joseph woke from sleep, he did as the angel of the Lord commanded him: he took his wife, but knew her not until she had given birth to a son. And he called his name Jesus.

In those days a decree went out from Caesar Augustus that all the world should be registered. This was the first registration when Quirinius was governor of Syria. And all went to be registered, each to his own town.

And Joseph also went up from Galilee, from the town of Nazareth, to Judea, to the city of David, which is called Bethlehem, because he was of the house and lineage of David, to be registered with Mary, his betrothed, who was with child. And while they were there, the time came for her to give birth.

And she gave birth to her firstborn son and wrapped him in swaddling cloths and laid him in a manger, because there was no place for them in the inn.

The Nativity *in Banska Stiavnica, Slovakia by P. J. Kern. Image © Sedmak/iStock*

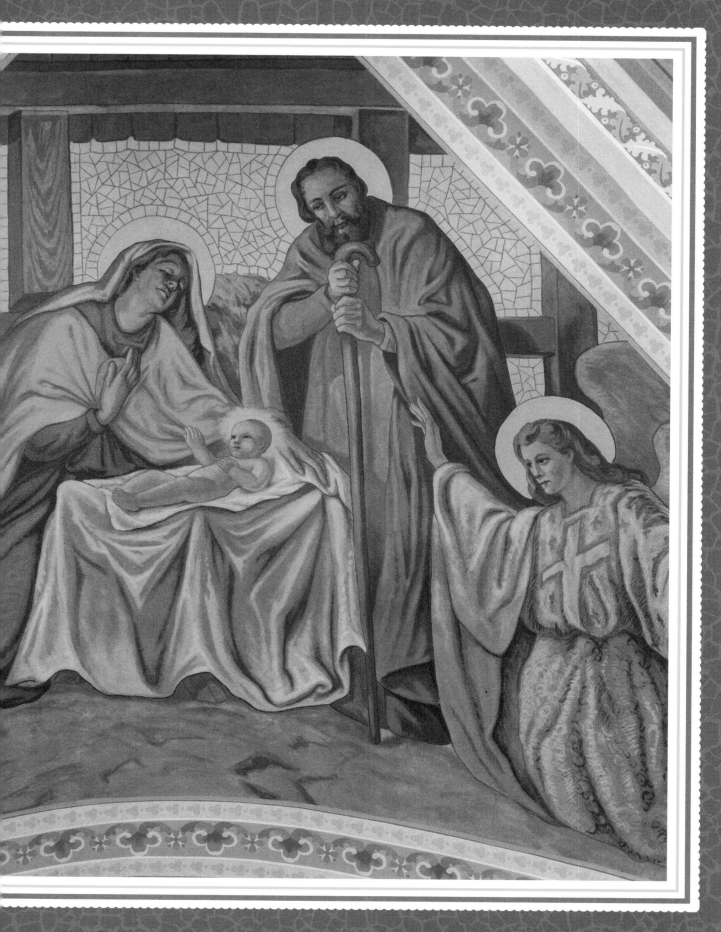

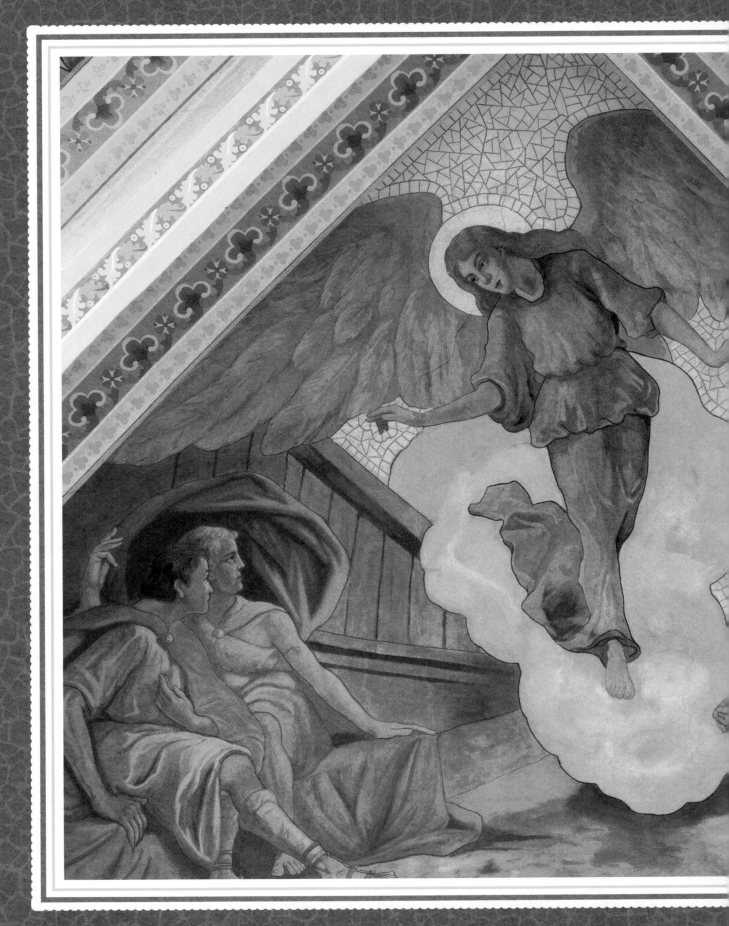

"But you, O Bethlehem Ephrathah, . . . from you shall come forth for me one who is to be ruler in Israel, whose coming forth is from of old, from ancient days."

—MICAH 5:2

The Shepherds

Luke 2:8–20

And in the same region there were shepherds out in the field, keeping watch over their flock by night. And an angel of the Lord appeared to them, and the glory of the Lord shone around them, and they were filled with great fear.

And the angel said to them, "Fear not, for behold, I bring you good news of great joy that will be for all the people. For unto you is born this day in the city of David a Savior, who is Christ the Lord. And this will be a sign for you: you will find a baby wrapped in swaddling cloths and lying in a manger."

And suddenly there was with the angel a multitude of the heavenly host praising God and saying, "Glory to God in the highest, and on earth peace among those with whom he is pleased!"

When the angels went away from them into heaven, the shepherds said to one another, "Let us go over to Bethlehem and see this thing that has happened, which the Lord has made known to us."

And they went with haste and found Mary and Joseph, and the baby lying in a manger. And when they saw it, they made known the saying that had been told them concerning this child. And all who heard it wondered at what the shepherds told them. But Mary treasured up all these things, pondering them in her heart.

And the shepherds returned, glorifying and praising God for all they had heard and seen, as it had been told them.

THE APPARITION OF ANGELS TO SHEPHERDS *in Banska Stiavnica, Slovakia by P. J. Kern.*
Image © Sedmak/iStock

"For to us a child is born, to us a son is given; and the government shall be upon his shoulder, and his name shall be called Wonderful Counselor, Mighty God, Everlasting Father, Prince of Peace."

—ISAIAH 9:6

The Wise Men

Matthew 2:1–12

Now after Jesus was born in Bethlehem of Judea in the days of Herod the king, behold, wise men from the east came to Jerusalem, saying, "Where is he who has been born king of the Jews? For we saw his star when it rose and have come to worship him."

When Herod the king heard this, he was troubled, and all Jerusalem with him; and assembling all the chief priests and scribes of the people, he inquired of them where the Christ was to be born. They told him, "In Bethlehem of Judea, for so it is written by the prophet: 'And you, O Bethlehem, in the land of Judah, are by no means least among the rulers of Judah; for from you shall come a ruler who will shepherd my people Israel.'"

Then Herod summoned the wise men secretly and ascertained from them what time the star had appeared. And he sent them to Bethlehem, saying, "Go and search diligently for the child, and when you have found him, bring me word, that I too may come and worship him."

After listening to the king, they went on their way. And behold, the star that they had seen when it rose went before them until it came to rest over the place where the child was. When they saw the star, they rejoiced exceedingly with great joy.

And going into the house, they saw the child with Mary his mother, and they fell down and worshiped him. Then, opening their treasures, they offered him gifts, gold and frankincense and myrrh. And being warned in a dream not to return to Herod, they departed to their own country by another way.

THE THREE MAGI *in Banska Stiavnica, Slovakia by P. J. Kern. Image © Sedmak/iStock*

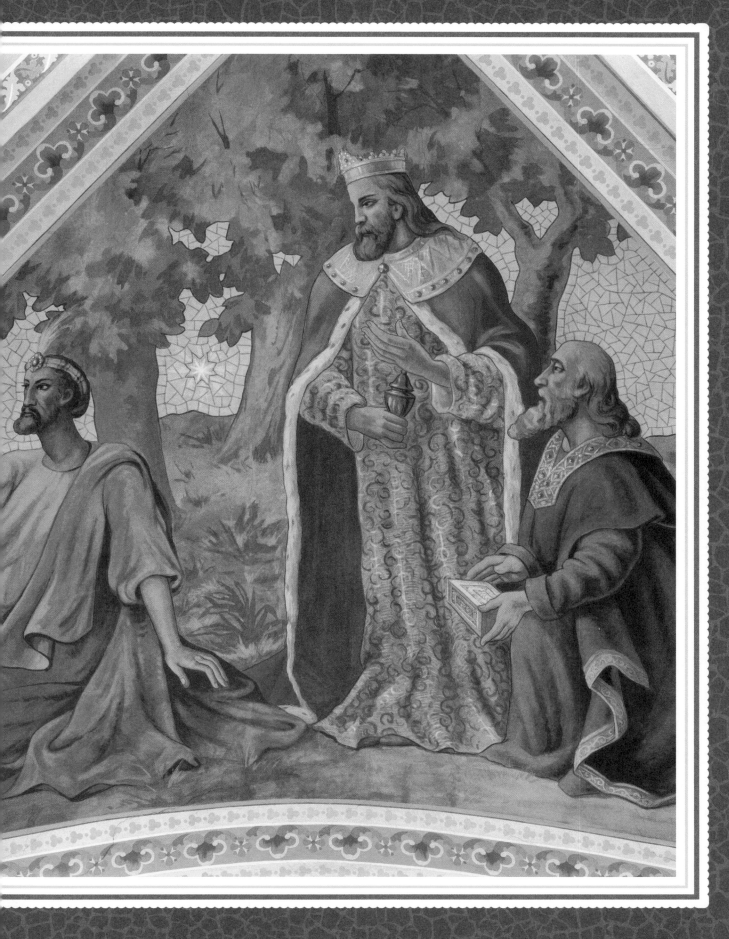

To the Three Kings

Evelyn Waugh

How laboriously you came,
taking sights and calculating
where the shepherds had run barefoot!
Yet you came and were not
 turned away.

For His sake
who did not reject your curious gifts,
pray always for the learned,
the oblique, the delicate.

Let them not be forgotten
at the throne of God
when the simple
come into their kingdom.

The Wise Men's Story

Lola S. Morgan

How shall we say if suddenly the sky
was newly starred or if our hearts were high
with visions of a destiny that led
us on although we questioned where and why?

We followed love, and we were comforted
on that long journey by a light that fed
our souls with faith, which did not fade or die,
a light whose source lay on a manger bed.

We hoped to find a child but did not know
He would be in a stable, poor and small,
but filled with joy so great it seemed to flow
like music, making every dream grow tall.

We are three kings who sought a palace door,
but knelt, instead, to worship on a stable floor.

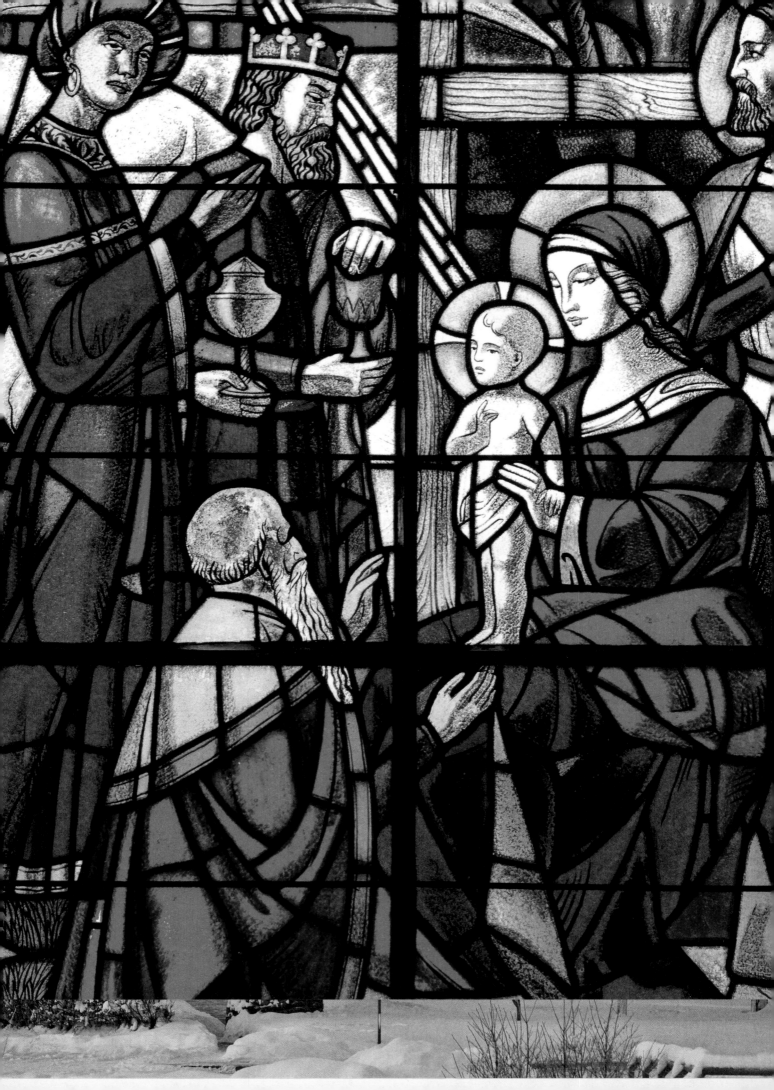

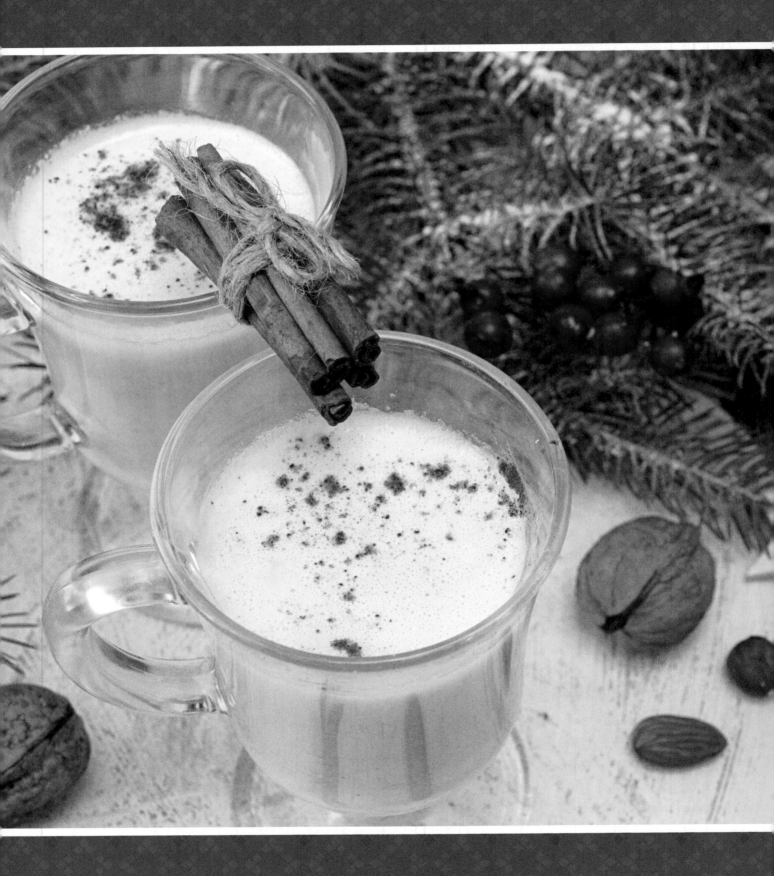

A Christmas Blessing
Rebecca Barlow Jordan

May this house be a home where love dwells,
where all who live may know the joys of every season
no matter where we go.
May the people who live here be happy;
may peace warm every heart;
and may Christmas abide in the rooms inside
as we celebrate the birthday of our Lord.

Christmas Tradition: Boiled Custard
Andrew L. Luna

Only a few traditions of life define what Christmas is, or ought to be. Down South, one tradition we call a "heavenly concoction" is synonymous with the holiday: boiled custard. It should be clearly noted for any Northerners that boiled custard is definitely not eggnog.

After Christmas dinner in Florence, Alabama, our whole family—Grandmother, Mom, Dad, sisters, brothers, aunts, uncles, and various assorted cousins and kin—gathers in the living room to "have the tree." This is our ritual of exchanging gifts. Toward the end of the gifts, Grandmother slips out to the kitchen, which is our signal to start clearing away all of the paper, ribbons, boxes, and bows. Once cleared, Grandmother enters the room with a large silver tray, loaded with glass cups surrounding a glass punch bowl filled with boiled custard.

Gathered round the table, we jostle to grab a cup and watch as Grandmother dips the ladle into the bowl, brings it up full of the cool, golden, frothy goodness, then lets it cascade into cup after cup until each guest is served. After everyone's cup is filled, we raise them all in a toast to each other. "Merry Christmas, and may God bless us every one!"

Image © Two Meerkats/AdobeStock

Christmas at Melrose

Leslie Pinckney Hill

Come home with me a little space
and browse about our ancient place,
lay by your wonted troubles here
and have a turn of Christmas cheer.
These sober walls of
 weathered stone
can tell a romance of their own,
and these wide rooms of
 devious line
are kindly meant in their design.
Sometimes the north wind
 searches through,
but it shall not be rude to you.
We'll light a log of generous girth
for winter comfort, and the mirth
of healthy children you shall see
about a sparkling Christmas tree.
Eleanor, leader of the fold,
Hermione with heart of gold,
Elaine with comprehending eyes,
and two more yet of
 coddling size—

Natalie pondering all that's said,
and Mary with the cherub head—
all these shall give you
 sweet content
and care-destroying merriment,
while one with true madonna grace
moves round the glowing fireplace
where Father loves to muse aside
and Grandma sits in silent pride.
And you may chafe the
 wasting oak
or freely pass the kindly joke,
to mix with nuts and
 homemade cake
and apples set on coals to bake.
Or some fine carol we will sing
in honor of the Manger King.
These dear delights we fain
 would share
with friend and kinsman everywhere,
and from our door see them depart
each with a little lighter heart.

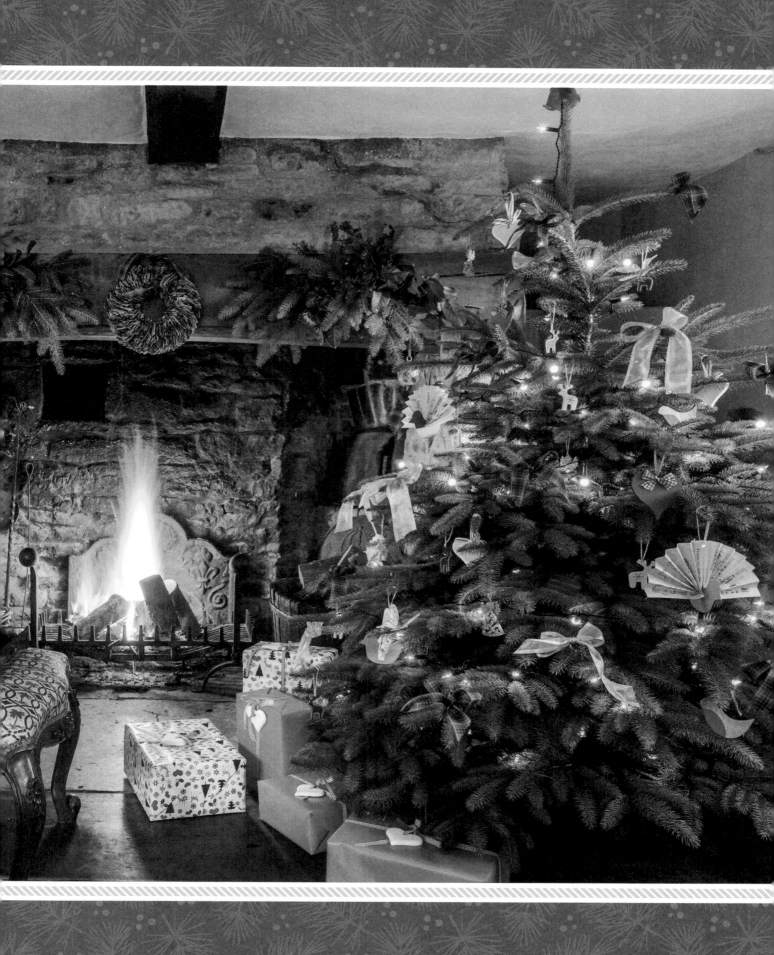

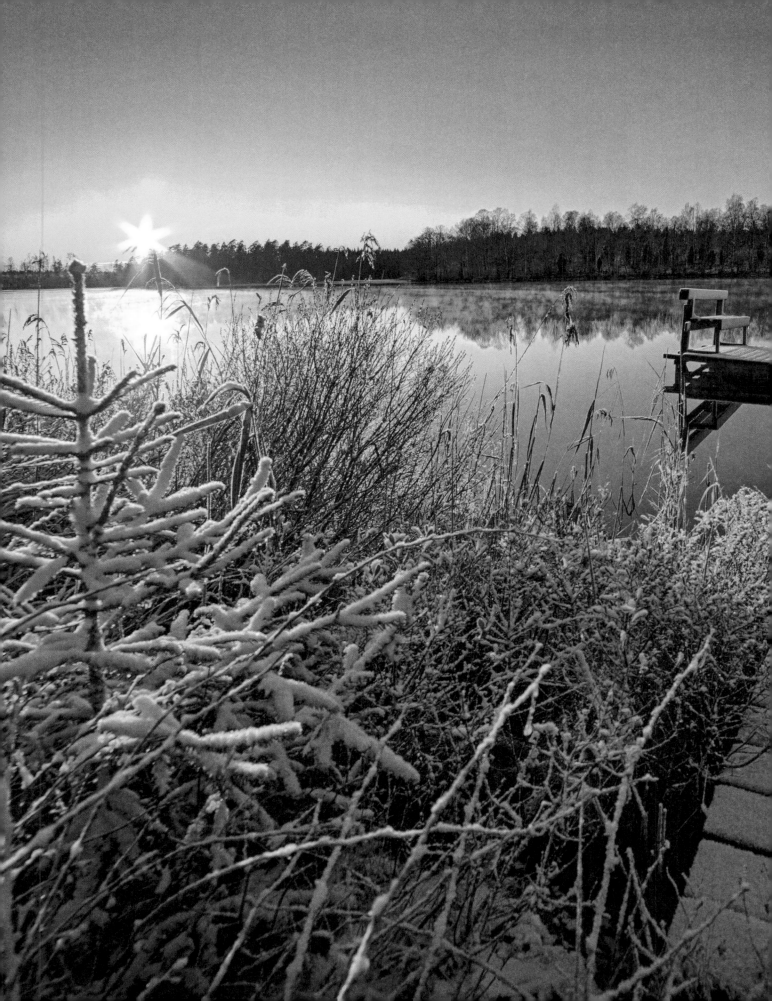

A Christmas Walk

Deborah A. Bennett

The lake in winter offers up everything at once: white gulls and the azure sky and the sound of infinite water molding the shore. My coat feels like nothing is around me; a gale blows so cold, the world is frozen in its wake. I hold my mouth open in faith that the next breath will come and wrap my arms closer in hope of heat. I had taken to walking the beach to escape the holiday—or to find it hidden somewhere in the shadows of pine trees stretching on the printless sand, decorated with seashells and sand dollars and the silver-blue skeletons of crayfish and crabs.

I walk as slowly as the wind allows, listening to the pounding of the waves on the rock wall with a cadence like heartbeats. The sun hovers on the horizon, and the entire beach is bathed in golden light. I lift a shell from the grass, snowflakes sweep past me and hang over the sand dunes like a veil. The city's tall buildings and neon signs disappear behind the fog like a hovering mirage. This was the feeling I had come for. The feeling of being utterly alone, under my own patch of gray-blue sky, alone, free to breathe in spite of my worries.

A peace beyond words comes over me. A serenity beyond the gifts and the decorating and the cooking of a perfect meal. I gaze at the once moss-sheathed shore wall, remembering it thick with vines and leaves in better weather. Not far from there a sandman stands with charcoal eyes and a smile and an icy carrot nose. Surprised by the sound of my own laughter, it sounded distant as if it had come from somewhere deep inside, from years ago.

As the wind settles to a breeze, I turn to watch the moon rise, the sky glowing as pink as the inside of a shell. A neighbor whistles for her dog, another stands frozen on her balcony in the fading sun, watching the clouds, the white gulls, suspended in the evening light, and the mist, trembling over the turquoise waves.

Now there were lights in windows, glowing yellow and warm, like candles burning on the windowsills. They seem like warm arms and smiles, like kindness and angels bending near. Suddenly, there was peace on earth, beginning with the peace inside of me on the shore of Christmas Day.

Bits & Pieces

For it is in giving that we receive.
—*Saint Francis of Assisi*

When we were children, we were grateful to those who filled our stockings at Christmastime. Why are we not grateful to God for filling our stockings with legs?
—*G. K. Chesterton*

Christmas is based on an exchange of gifts, the gift of God to man—His unspeakable gift of His Son—and the gift of man to God when we present our bodies a living sacrifice.
—*Vance Havner*

Every good gift and every perfect gift is from above and cometh down from the Father of lights, with whom is no variableness, neither shadow of turning.
—*James 1:17*

Christmas is here, merry old Christmas, gift-bearing Christmas, day of grand memories, king of the year!
—*Washington Irving*

Thanks be to God for his inexpressible gift!
—*2 Corinthians 9:15*

*G*ood news from heaven the angels bring,
glad tidings to the earth they sing;
to us this day a Child is given,
to crown us with the joy of heaven.
—*Martin Luther*

*H*e was created of a mother
whom He created. He was
carried by hands that He
formed. He cried in the
manger in wordless infancy,
He the Word, without whom
all human eloquence is mute.
—*Saint Augustine*

*T*he giving of gifts is
not something man invented.
God started the giving spree
when He gave a gift beyond
words, the unspeakable
gift of His Son.
—*Robert Flatt*

*Y*ou can never truly
enjoy Christmas
until you can look
up into the Father's
face and tell Him
you have received
His Christmas gift.
—*John R. Rice*

*A*ll the Christmas
presents in the world are
worth nothing without
the presence of Christ.
—*David Jeremiah*

Through My Window

The Joy of Christmas Past

Pamela Kennedy

A friend of mine says that putting up Christmas decorations always feels like an exciting adventure but taking them down seems like an unwelcomed chore. Normally I might agree, but this past year my post-holiday cleanup became an occasion for delight. Let me explain. We had six adults and four young children (ages nine, six, five, and two) all together in a fifteen-hundred-square-foot beach house for three days to celebrate Christmas. It was a joyfully noisy experience juggling playtimes, mealtimes, and bedtimes for four little cousins and their parents as well as for my husband and myself. In the midst of the merriment, there was very little time for reflection; but after they had all departed and I began to tidy up the house, sweet memories surprised me everywhere.

Out on the deck, a melting snowman drooped at an awkward angle, his seashell smile slipping a bit. One of his arms had detached, and his carrot nose sat on his slumping chest. I recognized my husband's missing plaid muffler, tied in a frozen knot around the diminishing pile of snow. Inside it was obvious that two-year-old Helen had enjoyed the nativity scene when I discovered one of the Magi riding the cow, Mother Mary in the manger, and Baby Jesus atop the stable roof. Across the room a dozen embroidered satin horse ornaments had been liberated from the Christmas tree and were lined up in pairs where six-year-old Evelyn had attached them with ribbon reins to an empty gift box bearing a stuffed Santa. I chuckled as I recalled her aunt doing a similar thing when she was small. Over on the end table, the family of sock snowmen had traded hats, and one of them was standing on his head. There were toothpaste globs on the bathroom wall and Christmas stickers on the bedsheets, cracker crumbs in the couch cushions, and a half-eaten candy cane stuck to the bathmat. Clearly, fun was had by all!

As I tucked away the ornaments and decor, I smiled, thinking about all the unscripted moments that will also be tucked away in my memories of this Christmas. Four children in matching green PJs lined up with their legs apart, making a tunnel for remote control cars to race through. A toddler bouncing up and down in a rainbow tutu, singing off-key show tunes while waving a wand. A newly literate six-year-old snuggled in an oversized armchair, reading about a puppy to an adoring two-year old. A nine-year-old patiently explaining the finer points of putting together a model car to his frustrated five-year-old cousin. These little folks who hadn't seen each other in almost two years

quickly bonded over silliness and sparkling lights as their parents caught up on careers and common parenting challenges.

This was the very essence of Christmas, family times and fun with a healthy dose of wonder. But how could it be, I thought, that our children are now grown and have children of their own? Wasn't it just a few Christmases since I had watched them rip open their packages and squeal in awe over the newest toy or a coveted treasure? How did that little girl become such a confident and tender mother when not long ago she was rocking her favorite doll baby and tucking it into a small wooden cradle? Recalling my son patiently guiding his own son as he struggled to figure out a complicated construction set, I remembered many a past Christmas when he was the one needing help fitting the pieces together. What is this magical quality of time that causes it to compress as we observe our families stretching and growing? I shook my head and sighed with a bit of melancholy as I pushed the last few boxes of decorations into the storage closet.

Finally, the house was tidied up and back in order. Evidence of Christmas stowed for another year. It was time to move on and get ready for the next adventure. Then I spotted a board book

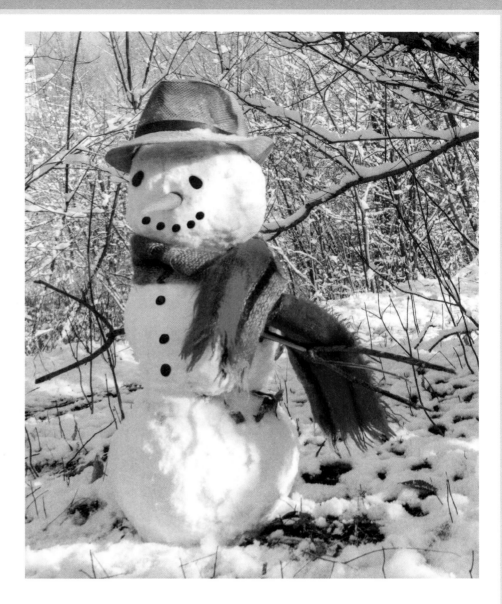

peeking out from under the couch. Reaching for it, I inadvertently pressed a button on the cover and a chorus of childish voices blasted "Joy to the World!" at full volume. Laughing, I tucked it back into the bookshelf. That's what it's all about, I realized, and that's why all those memories, past and present, blend into one large Christmas collage. The love and laughter of family, the craziness and clutter. Those are the never-ending stories of Christmas—the holiday gifts that continue to tuck special joys into every corner of our world.

How Joyfully
J. Falk

Oh, how joyfully, oh, how merrily,
Christmas comes with its grace divine!
Grace again is beaming,
Christ the world redeeming;
hail, ye Christians,
hail the joyous Christmastime!

ISBN: 978-0-5460-0231-4

Published by Ideals
Hachette Book Group
1290 Avenue of the Americas
New York, NY 10104

Printed and bound in the U.S.A. · LSC-W

Publisher, Peggy Schaefer
Editor, Patricia A. Pingry
Senior Editor, Melinda Rathjen
Designer, Marisa Jackson
Associate Editor & Permissions, Kristi Breeden
Copy Editor & Proofreader, Rachel Ryan

Cover: Image © GAP Photos
Additional art credits: Art for "Bits & Pieces" by Emily van Wyk.
Inside front cover: *Church in Snow* by Susan Rios. Image © Susan Rios/Artlicensing.com
Inside back cover: *Christmas Presence* by Bob Fair. Image © Bob Fair/Artlicensing.com

Want more homey philosophy, poetry, inspiration, and art? Be sure to look for our annual issue of *Easter Ideals* at your favorite store.

Join a community of *Ideals* readers on Facebook at: www.facebook.com/IdealsMagazine
Readers are invited to submit original poetry and prose for possible use in future publications. Please send no more than four typed submissions to: Hachette Book Group, Attn: Ideals Submissions, Hachette Nashville, 830 Crescent Centre Drive, Suite 450, Franklin, TN 37067. Editors cannot guarantee your material will be used, but we will contact you if we do wish to publish.

ACKNOWLEDGMENTS

JEFFERS, ROBINSON. "Only An Hour" from *The Collected Poetry of Robinson Jeffers, Volume Three: 1939–1962*. Edited by Tim Hunt. Copyright © 1938, renewed 1966 by Donnan Jeffers and Garth Jeffers. All rights reserved. Used with the permission of Stanford University Press, www.sup.org. LEWIS. C.S. "The Nativity" by C.S. Lewis. Copyright © 1948 C.S. Lewis Pte. Ltd. Reprinted by permission. MARSHALL, PETER. "For Our Children" excerpt from *The Prayers of Peter Marshall*, by Peter Marshall. Copyright © 1954, 1982. Used by permission of Chosen Books, a division of Baker Publishing Group. SMITH, LILLIAN. "When Pecans Started Falling" from *Memory of a Large Christmas* by Lillian Smith. Copyright © 1962 and renewed 1990 by Lillian Smith. Used by permission of W.W. Norton & Company, Inc. OUR THANKS to the following authors or their heirs for permission granted or for material submitted for publication: Shirley Bachelder, Winnie Barnett, Deborah A. Bennett, Anne Kennedy Brady, H. Wilbur Carroll, Edna Jaques, Jewell Johnson, Rebecca Barlow Jordan, Pamela Kennedy, Andrew L. Luna, Lola Neff Merritt, Virginia Blanck Moore, Lola S. Morgan, Mamie Ozburn Odum, Patricia A. Pingry, Solveig Paulson Russell, Marion Schoeberlein, Mina Morris Scott, Gladys Shuman, Eileen Spinelli, Evelyn Waugh, Gladys Wellman, Mary Wells, Helen Welshimer, Elisabeth Weaver Winstead.

Scripture quotations are taken from ESV® Bible (*The Holy Bible, English Standard Version®*), copyright © 2001 by Crossway, a publishing ministry of Good News Publishers. Used by permission. All rights reserved.

Every effort has been made to establish ownership and use of each selection in this book. If contacted, the publisher will be pleased to rectify any inadvertent errors or omissions in subsequent editions.